PARANORMAL

BRIGHTON AND HOVE

PARANORMAL

BRIGHTON AND HOVE

Including Stories from Portslade, Southwick,
Shoreham-by-sea, Steyning, Rottingdean,
Woodingdean, Seaford and Newhaven,
and much more…

JANET CAMERON

AMBERLEY

First published 2009

Amberley Publishing Plc
Cirencester Road, Chalford,
Stroud, Gloucestershire, GL6 8PE

www.amberley-books.com

Copyright © Janet Cameron 2009

The right of Janet Cameron to be identified as the
Author of this work has been asserted in accordance
with the Copyrights, Designs and Patents Act 1988.

ISBN 978 1 84868 716 5

British Library Cataloguing in Publication Data.
A catalogue record for this book is available from the
British Library.

Typeset in 10pt on 12pt Sabon.
Typesetting and Origination by FONTHILLDESIGN.
Printed in the UK.

CONTENTS

ACKNOWLEDGMENTS

Thanks to the following people for their invaluable help and support in the writing of this book: Nick Baker, Elle, Gareth Cameron, Phillip Fifton, Susannah Greaves, John McPherson, Dean Page, Pamela Rose, Dan Vidler, and especially my friend, local historian Geraldine Curran, whose assistance while writing this book has been, well, out of this world! And, finally, my patient editors Sarah Flight and Jessica Andrews.

INTRODUCTION

It's hardly surprising that the city of Brighton and Hove, together with its outlying villages, is claimed to be one of the most haunted places in Britain. Some say Brighton beats both London and York for documented paranormal sightings. Of course, not all ghostly experiences are recorded, and this is sometimes because people are afraid they will be ridiculed by the more sceptical among us.

Discoveries have been made confirming that people have been living in this part of the country for over 4,000 years, the first settlement believed to be in Whitehawk. The Steine was marshy land due to the confluence of two rivers, one running down the present-day London Road and the other down the Lewes Road. Here, close to where the rivers came together, rested a tribal stone (the word 'steine' means 'sacred stone'). This fascinating information was the subject of a talk by a Miss Candlin to the Patcham Women's Institute way back in 1961.

Brighton's old name, Brighthelmstone (or alternatively, Brighthelmston, without the 'e'), is derived from the Saxon for *Beorhthelm's Tun* or *Brihthelm's Tun*, meaning 'the farm of Beorhthelm' (*Old Brighton, Old Hove, Old Preston* by Frederick Harrison and James Sharp North, Flare Books, 1974). Until around the 1850s, according to John Bishop's book, *A Peep into the Past,* Hove was pronounced 'Hoove'.

It's widely accepted that ley lines snake across Brighton between ancient and sacred sites. These cross over at Brighton around the Old Steine. Some people claim that these ley lines follow the tracks of commonly travelled prehistoric pathways and produce massive psychic energy, giving rise to paranormal phenomena and eccentricity — the existence of which few Brightonians would doubt.

In this book, I have retold the old stories, updating them wherever possible, and I have managed to include some more modern reports from the media as well as fresh material using the personal stories of local people. Of course, no one can know for sure what is true or not true. Some of the stories are from legend and folklore, some are from newspaper accounts and others were told to me personally. It's not possible, of course, to verify all the evidence in a book of this nature, but I do accept that all the personal stories told to me were sincerely believed and recounted as accurately as possible by the tellers. It is up to you to make of them what you will, but to reserve judgement and to continue to believe in what is right for you, whatever that may be. Meantime, I hope you enjoy all the stories.

Thanks to everybody who generously shared their spooky experiences.

CHAPTER 1

WHAT IS A GHOST?

Some people believe a ghost is the residue of emotional energy or a great trauma that has impressed itself on a building or a place. Nothing is ever destroyed in our Universe, it simply changes into something else, and so it is with the human spirit. And, sometimes, we are lucky (or unlucky) enough to see this residue energy as a ghost, just like an ongoing memory. At the atomic level, everything is always in a state of flux and energy is trapped and stored. That's probably the most scientific theory, but there are other beliefs worth considering.

Many people think ghosts are simply troubled souls, trapped on our plane, unable to cross over to the other side for some disturbing reason; maybe they have unfinished business on the earthly plane or had a tragic end and cannot move on. Another possibility is that they don't yet know they are dead. Some people believe that certain ghosts want retribution or revenge for wrongs done to them in their physical lifetime here on earth. Ghostly apparitions can appear to glide a few feet above the ground or appear cut off at the knees because the ground level was lower or higher at the time they existed on earth.

Of course, ghosts take many forms. Poltergeists — the word means 'noisy spirits' — can be mischievous ghosts and are often attracted to places inhabited by children. They move, throw and hide things, switch lights on and off, turn on domestic equipment, start fires (spontaneous combustion?) and slam doors. Some people believe they are the ghosts of those who once lived in the house, who, because they don't know they are dead, haunt their former home to try to oust the 'intruders'.

The mayhem caused by a poltergeist can seriously disturb living humans and some even move house to escape these unwelcome attentions. This doesn't always solve the problem because, although it appears to have achieved its goal, the poltergeist sometimes follows the escapees to their new home and continues playing its tricks. It's also claimed that some people attract such manifestations because their vibrations are particularly sensitive to the phenomenon, rather similar to the vibrations of mediums.

Although the labels 'ghost' and 'spirit' are often interchanged, in the strictest sense a ghost is a manifestation 'in limbo'. In other words, the soul hasn't moved on to the other side. Spirits, on the other hand, have moved over but may occasionally return, perhaps to comfort a loved one but sometimes for more sinister reasons! There are other explanations, for example, that apparitions are a 'live intelligence', while a haunting is merely a 'recording'.

However you choose to label these strange phenomena, the boundaries are blurred, while the final result is the same: a sense of wonder and a cold shiver down your spine.

The word 'paranormal' covers a number of other strange occurrences. It means simply anything that cannot be explained by normal objective investigation, in other words, it is supernatural and outside the realms of science to explain. Besides ghosts, poltergeists and communication with the dead, other examples covered in this book are:

* The power of witchcraft and pagan rites
* Prediction of the future
* Orbs that float and hover in houses and in the sky
* The mystery of crop circles
* Experiences of regression to a previous life or lives, possibly evidence for reincarnation
* Telepathy, meaning the transference of thought from one person to another
* Extra-sensory perception or ESP (the ability to acquire information without reference to any physical means, this is your sixth sense, or gut instinct. Telepathy, as mentioned above, is an aspect of ESP.)
*Psychokinesis, or telekinesis (the ability of the mind to influence physical systems. Examples of psychokinesis include moving an object, or distorting it — like Uri Geller bending forks — or influencing the outcome of a random number system, like coin-flipping, shuffling cards or throwing dice).
* Teleportation (the transfer of matter from one point to another, generally instantaneously. In other words, an out-of-body experience).

We should also consider that sometimes people invented ghost stories because they had a hidden, self-serving agenda. For example, smugglers would spread rumours of some scary apparition or unearthly monster to scare others away, either from where they stashed their loot or from the areas where they picked up the illicit cargo.

I'm often asked if I believe in ghosts. I've never actually seen one (in spite of a few weird and inexplicable experiences) so I keep an open mind. I think that *sometimes* there's a genuine scientific explanation — we just don't know what it is. But whether some of these stories are fully true or partly legend, they are still part of our folklore and they almost always have a historical context. That, for me, is enough. Especially as some accounts have a truly uncanny resonance with reality and truth, for example the 1950's case of the Southwick Airman in Chapter 9. This seems to defy any rational explanation and it's hard to doubt the sincerity of the tellers. Also, the scope of the paranormal — or purely scientific but beyond our understanding — is far-reaching and incredibly exciting, and this is aptly expressed by the incomparable William Shakespeare, who wrote 'There are more things in heaven and earth, Horatio, than your philosophy has ever dreamt of.'

Brightonians love ghosts and phantoms so much that some even dress up to look like them. ©
Gareth Cameron.

CHAPTER 2

GHOSTS AND POLTERGEISTS IN PUBS, INNS AND BARS

As noisy meeting places for smugglers, gamblers and vagabonds, the pubs and inns in and around Brighton and Hove have a colourful, complicated and very bloody history. Formerly called alehouses or taverns, they were a magnet to soldiers, prostitutues, thieves and all sorts of rough and seedy characters. Some pubs, to entice more customers, actually became brothels, gambling dens or venues for blood sports such as cock-fighting and dog-fighting. Others even became proxy courthouses for felons to be tried for their crimes. So it's no surprise to find that many pubs and inns are haunted by scary spooks and weird phenomena. Below are just a few of them.

Battle of Waterloo Pub, Brighton

The Battle of Waterloo pub in Rock Place claims to be haunted by a cloaked figure that hangs around the men's toilets. This ghost is thought to be that of an unfortunate man, probably the chauffeur of a mayor, who had been murdered by a highwayman after leaving the pub. Highwaymen often lay in wait for stagecoaches in the 1700s. In the latter part of the century, according to Rosamond Bayne-Powell on www.ourcivilisation.com, Brighton, by now a fashionable resort, became the first place from which a coach ran to London on a Sunday. People believed that on a Sunday highwaymen would be 'resting'. Or maybe even relaxing over a beer at the Battle of Waterloo pub! Mounted robbers were called highwaymen, while those on foot were called footpads.

The Bedford Tavern, Brighton

Close to the seafront, at 30 Western Street, the Bedford Tavern has a tragic ghostly presence. A pregnant woman, it's said, gave birth to a stillborn child during the night and by the morning she too was dead. It's claimed her ghost now haunts the pub.

The Black Lion's Burned Martyr, Brighton

The cellar of The Black Lion, at 14 Black Lion Street, is claimed to be haunted by the ghost of a famous martyr, one of those brave Sussex stalwarts named on the Memorial in the East Sussex county town of Lewes. Deryk Carver was burned, either at the stake or in a barrel, close to The Star Inn, now Lewes Town Hall, in what is known as the Marian Persecutions.

Carver, who was a Flemish immigrant, lived in Brighton for around nine years before his death in 1555. At that time, Mary I had succeeded her father, Henry VIII. Mary's obsession was to convert the country back to Roman Catholicism, and she went about it with as much zeal as her father previously overturned the faith in order to marry the ill-fated Ann Boleyn. It's said that 300 Protestants were burned at Mary's hands. But Deryk Carver's sympathies lay with the Protestant cause and he was in exile from France because of his beliefs. Carver became wealthy as he made a name for himself as a brewer; he is thought to have been the first brewer in Brighton. The Black Lion brewery derives its name from the famous Black Lion of Flanders. Deryk Carver had five children, although there seems to be no mention of a wife (possibly she had died by this time).

Carver was arrested by the Sherriff, Sir Edward Gage, while praying with some friends, and he and three others were taken to Newgate Prison. Carver refused to recant his belief that the Sacrament of the Altar did not represent the blood and body of Christ, nor did it represent sacrifice leading to salvation for a Christian. When Bishop Bonner received a

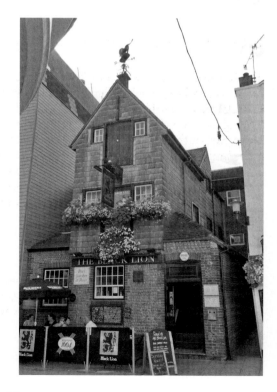

The Black Lion pub, where the ghost of the famous martyred brewer Deryk Carver still lingers in the cellar. © Gareth Cameron.

letter alleging Carver's heresy, the devout man's fate was sealed. Of the three friends tried with him, two were burned, but at different places, and one was reprieved.

The brewery was established in 1546 but was demolished in 1968 and rebuilt in 1974 using some of the original materials. Despite this extensive re-development, since the 1940s there have been reports of sightings of Deryk Carver's ghost in the cellar. In 1995, a builder claimed to have seen the ghost and later, in 2006, a manager reported he felt a presence on several occasions when he went into the cellar. Some people believe the martyr revisits The Black Lion each year on the anniversary of his execution. According to *The Argus* of 28 November 2006, 'There are said to be ghostly noises and goings-on in the pub throughout the year but on July 22, the anniversary of Carver's death, they are said to reach fever pitch.'

Pauline Davy, manager of The Black Lion for the previous three years preceding the above-mentioned *Argus* report, said there was definitely a spooky presence. 'Everybody talks about the ghost and although I've never seen it, there is a place in the cellar where we can feel something. It is a scary presence, as if something may have happened there. It's difficult to explain.' One member of staff reportedly left his mobile phone in the pub but was too scared to go back in to retrieve it — not with all the lights out!

It is said that when brave Deryk Carver was being burned, in a last act of defiance he tossed his Holy Bible into the crowd of spectators. His name was recorded in *The Book of Martyrs* by John Foxe, which was published five years after the death of the queen: 'Bloody' Mary.

The Bow Street Runner, Hove

This friendly pub in Brunswick Street West was once a police station and the building next to it (to your right if you are facing the pub) was the original town hall. Some people dispute that this was once a police station, although another account does seem to back up the original claim; regulars at the pub say there was once a hatch between the police station and the town hall so court documents could be passed through before prisoners appeared before the Bench. According to the 1901 census, the pub was called The Station Inn but eventually the landlord got tired of the frequent phone calls with train enquiries and changed the name to The Bow Street Runner.

Disturbances escalate in this pub whenever there's a change of ownership. The bar staff report encountering a female ghost who always appears in white. It's thought she may have been incarcerated in a cell in the police station for being drunk and disorderly and maybe even died there. She causes glasses to fall off the shelves, and once, when a customer asked for a pint, the landlord, Robbie, went to pick up a glass and it shattered in front of his eyes before he had even touched it.

On another occasion, a member of staff was using a hair dryer upstairs and suddenly it switched itself off and she felt a cold hand press down on the back of her neck. Bev, another member of the bar staff, says she was standing at the counter when something cold brushed sideways across the back of her calves. Shocked, she jerked back and a colleague asked her what was the matter. 'I wouldn't have said anything,' said Bev 'it was only because my friend saw my reaction that I felt able to say what happened.'

Some time later, Bev put out her hand to pick up a gin glass. This kind of glass is thick and sturdy and difficult to break unless smashed against a hard surface — but Bev

hadn't even touched the glass before it shattered into a thousand pieces right in front of her eyes, like a mini-explosion. 'But I didn't even touch it,' she said, 'I had only just put out my hand towards it.' At this time, Bev had just started occupying the flat upstairs and the thought of what had happened has given her some sleepless nights. Clearly the Lady in White doesn't care for anything that disrupts her haunting.

In her book, *A History of Hove* (1979, published by Unwin Bros. Ltd), author Judy Middleton mentions The Station Inn in Brunswick Street West. She confirms that tradition has it that this was the old police station. The Brunswick Commissioners erected their own building on Brunswick Street West on a piece of land costing them £280. There was also a shed erected and this was later converted into the police station. So, it seems this may have been the origin of the Bow Street Runner.

The Brunswick, Hove

It's claimed that the Brunswick, a fine Regency-style pub at 1 Holland Road, Hove, has a ghost that is very fond of one particular old picture. If anyone moves it — even just a little — the ghost throws a tantrum and starts chucking stuff around, like glasses and bottles. Maybe this is a ghost of a former landlord or landlady for whom the picture meant a great deal. It's common for ghosts of former residents of certain places to resent any changes made by the new incumbents.

Bugle Inn, St Martin's Street, Brighton

The Bugle Inn at 24 St Martin's Street reports a poltergeist that gets up to the usual poltergeist tricks of moving furniture around, flicking lights on and off and tampering with locks. Nobody seems too bothered about him as he seems fairly harmless, and he's been affectionately christened as 'Charlie' by the bar staff.

The Cricketers, Brighton

This pub is at 15 Black Lion Street and is one of Brighton's oldest pubs, said to date from the sixteenth century. The Cricketers is haunted by the ghost of a nun and a manager once reported a pale-faced man in a long black coat. One of them must be responsible for turning off beer taps and drifting off with the glasses. Sometimes glasses are swept off shelves, bottles are hurled around and doors slam, while footsteps are heard ascending stairs and then descending again.

Particularly spooky is the ghostly presence that haunts the ladies' toilets. Member of staff Nick Baker, whose brother-in-law was landlord of the pub for five years, describes how a young woman fled screaming out of the toilet. She was shaking with fright but eventually calmed down sufficiently to explain how something cold had brushed against her face. Apparently, as Nick explained, a woman took her own life in the toilet area, but this was more than a century ago so the reason for the tragedy is not known.

Ghost tour operator Malcolm Campbell said, in a report by Duncan Hall in *The Argus* dated 30 April 2008, 'There is a distinct feeling one is not alone. Little dogs

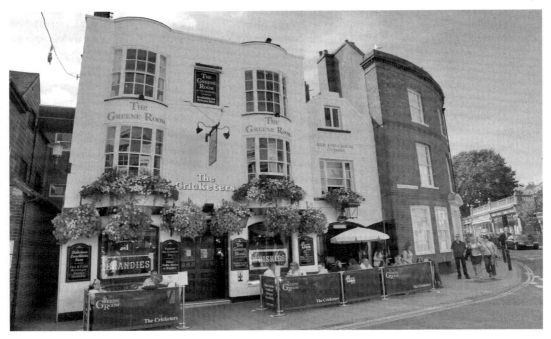

The Cricketers — a poltergeist and a spook in the women's toilet! © Gareth Cameron

become very, very sensitive in there. Shadowy figures have been seen on the staircase from the ground floor to the upper floors.'

The Lanes' grey nun is also claimed to hover around outside the pub from time to time, so if you're a clandestine smoker you might see her!

The Crown and Anchor, Shoreham

This pub at 33 High Street, Shoreham-by-Sea, is reputed to be on the site of a hanging. There were also ghosts of two children, a girl and a boy, who hid from the hanged man because they were scared of him. A son of a previous landlord was asleep in bed one night and got the fright of his life when he suddenly woke to see the ghost's legs dangling above him. Apparently, there had been a séance the night before and it is possible that this had evoked the apparition of the hanging man. There is a further claim that the ghost of a Spaniard haunts the pub, but whether this is the same ghost as the hanging man is not clear.

It's also claimed that there are smugglers' tunnels beneath the pub.

The Druid's Head, Brighton

The Druid's Head at 9 Brighton Place is said to date from 1510, so it's hardly surprising that this attractive and antiquated pub is haunted. The pub was once a venue for smugglers dealing in silk and liquor.

The Brighton Gazette, dated 12 January 1957, ran an account of an interview with the landlord at that time. Mr Les Walker explained that he had taken over the pub seventeen years ago from his father, i.e. around 1940. The pub was used by farmers coming from the fruit market, and they liked to have a rum and coffee, at 2*d* a time, and then spread themselves out in the bar and sleep. Les Walker showed *The Gazette*'s reporter (unnamed) two secret passages. The first was believed to go to the fish market by the Palace Pier and the second went in the direction of Old Steine and was believed to go to the kitchens of the Royal Pavilion. Smugglers, allegedly, brought their brandy along the first tunnel and then transferred it to the second tunnel *en route* for The Pavilion.

At some point early in the history of the inn, some young girls from a nearby convent were off to America but their vessel was caught in a gale and foundered just off the coast. All the passengers died in the storm. This seemed to Les Walker to be connected to a slim, boyish figure with a nun's hood that floated in and out of The Lanes near The Druid's Head. If anyone approached the figure it simply vanished, and no one had ever caught sight of its face. Strange noises in the bar at night alarmed the landlord and his wife. 'When I come down in the morning, I find several bottles scattered on the floor,' he said, but then added, hopefully, 'it could be the wind…'

Four other ghosts have been reported to haunt this ancient pub, which, according to *The Brighton Gazette*, was originally made from beach-stones mixed in with cement and has no proper foundation as we understand it today, being built virtually flat to the ground.

Druids were members of a mysterious sect who believed in the transmigration of the soul and reincarnation after death. They practised human sacrifice. This is an ancient carving found in a burial mound (location unknown).

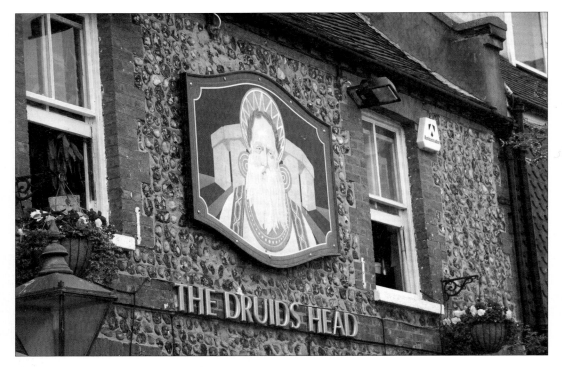

The Druid's Head's inn sign. © Gareth Cameron.

George IV is said to haunt the tunnel between the Pavilion and the old cellars belonging to the pub. A hooded monk occasionally makes an appearance. A smuggler was shot and killed by a customs officer as he tried to leave the cellar to escape through one of the tunnels in the 1700s. Apparently, he fell down the cellar steps and died and his ghost now haunts the cellar and plays tricks with bottles and glasses. The ghost of a lady in a red dress has been sighted by bar staff near the bar. She slowly disappears.

In a report dated 14 August 2008, bar manager Yvonne Roache spoke to a reporter from *The Argus*. 'The pub is named due to its proximity to the former sight of a stone circle once ascribed to the druids. I prefer to ignore the ghost stories. I don't like thinking about it, because I live above the pub,' she said.

Dr Brighton's, a Baby Boy and a Bad-Mannered Ghost — Kings Road, Brighton

A woman from Hove, with a gift of psychic awareness and who managed Dr Brighton's a few decades ago, picked up hostile vibes in certain rooms, whereas in other rooms the atmosphere was benign, even welcoming. She was unable to say what it was that was so frightening because she simply refused to enter any areas where she felt a hostile presence.

Dr Brighton's was once called The Star and Garter. It's claimed that a back-street abortionist operated here in the cellar in dark, filthy conditions. Desperate mothers were

Spirit rappings — a cover page to
sheet music, 1853.

forced to bring their children with them. One day, according to the story, a small
boy whose mother was undergoing her operation was left in the cellar. He fell over
and hit his head hard on a beer keg. Sadly, he died from his injury and it's said his
nineteenth-century ghost now haunts the cellar, and, even more chillingly, a child's
ghostly handprint has been witnessed on the window-glass. It's difficult to see how
this handprint could actually be identified as a ghost-print, unless no living child
had been in the vicinity at the time.

There have also been claims of knockings and tappings and of people being 'poked'.
Clearly, this is a very bad-mannered ghost who doesn't know — or doesn't care — that
poking people is rude. Some people say Dr Brighton's got its change of name from the
description of Brighton by the nineteenth-century novelist William Makepeace Thackeray.
Brighton Rock's author, Graham Greene, was once a regular visitor to the bar.

The Ferry Inn, Shoreham

Up until about the early 1990s, a mischievous spirit haunted The Ferry Inn in Shoreham-
by-Sea, and it definitely wanted to be the centre of attention, because it made a terrific
commotion. Then, perplexed staff discovered that beer casks and barrels had been
moved around in the cellar. The Ferry Inn used to be connected by tunnels to The
Waterside Inn on the opposite riverbank.

For the past sixteen years, with a change of management, the poltergeist has vanished and all is quiet, according to Mike, the present landlord, who heard all the stories from the previous owners. Of course, it's characteristic of poltergeists to follow the people they're haunting, so that might be the reason that the only noise in this pub nowadays is from the music and its happy customers.

The Fisherman's Rest, Brighton

The Fisherman's Rest at 124 Kings Road is run by Stefan and Simon, who claim that the pub is haunted. The pub can be found beneath The Granville Hotel, which is built on the site of some old Georgian houses. There are sudden icy chills, and when the young men run the CCTV footage they are amazed to see strange, indistinct shapes appear on-screen, for which there can be no other explanation but some sort of ghostly presence.

The Foundry, Brighton

Dating back to 1838, The Foundry, at 13-14 Foundry Street, Brighton, was originally called the White Horse. Then, in 1869, it became the Pedestrian's Arms. Now it's just The Foundry, a lovely, comfortable back street pub.

According to a report in *The Brighton and Hove Gazette* dated 5 October 1979 and entitled 'The Ghostly Spirit in the Real Ale Pub', the haunting was first discovered by Bill and Beryl Dye. Recently, the couple had installed real ale — and since that time the unwelcome spirit made its presence felt, lurking in the cellar. But it's not a very assertive ghost and doesn't seem to want to be seen.

'It's a tall, dark shadow,' Mrs Dye told *The Gazette* reporter. 'Ever since we changed the cellar to the real ale beer, it's been down there. When I am in the cellar in the morning, I feel somebody is looking over my shoulder. I look round and the shadow whips around the corner.'

Mr Dye, the thirty-five-year-old landlord, had also experienced this strange phenomenon. He says, 'It was really eerie. I was down in the cellar about midnight. There was nobody else in the pub but I saw this shadow moving around. I ran up the stairs like a bolt of lightning. I couldn't believe it.' Mr Dye emphasised that he was not the sort of landlord who 'saw pink elephants'. However, he was entirely freaked out by this weird encounter and the fact that things moved around in the cellar.

The couple had taken over the pub ten months previously and lived over the top. They'd considered exorcism, but as this was not an unpleasant apparition, they decided against it. As Mrs Dye explained, 'He never wanders upstairs.'

The Franklin Arms, Washington (West Sussex)

At Washington, on Chancton Farm in 1866, Saxon coins were found. For some time a 'treasure' was said to be hidden there, guarded by the ghost of an old man with a white beard. This isn't too far from the famous sacred site, Chanctonbury Ring, also said to be haunted by an ancient ghost that walked with head bowed down, while from his

A stop for liquid refreshment at the Franklin Arms in spooky Washington Village. The pub was a popular watering hole for day-trippers from London looking for some fun in Brighton. © Janet Cameron.

chin hung a long white beard, a similar description. But while the first ghost was said to be guarding the treasure, the walking ghost looked as though he was searching for something — and his search went on for centuries.

According to www.sussexhistory.co.uk, the treasure was eventually found during ploughing and the searching spectre disappeared, never to return.

Hangleton Manor Inn, Hove

The Hangleton Manor Inn at Hangleton Valley Drive, Hove, has a tragic ghost. A young female servant had a child, but her master, the lord of the manor, committed a brutal act by flinging the tiny baby out of an attic window of the pub. It could be this distraught girl's ghostly, disembodied hands reported to hover frantically around the building, exactly as though she is reaching out for her lost child.

According to *The Argus* dated 31 December 1951, the presence of the servant girl became a useful 'dollar earner', as the proprietor at that time, a Mr Gower, advertised in the States and expected some American visitors the following year. Even if the ghostly hands did not appear, the manor was considered one of the finest examples of Tudor architecture in Sussex. This fine house was built in 1540-1550 in the reign of Henry VIII. The building material came from the stones from Lewes Priory after Henry VIII's dissolution of the monasteries.

It's believed Hangleton Manor was connected by an underground tunnel to the nearby ancient Church of St Helen, dating back to Norman times. It's claimed the Church of St Helen is the oldest building in Brighton and Hove, and Hangleton Manor is the second oldest. The building fell into decline in the sixties but was rescued and renovated.

Hove Place

Hove Place at 36 First Avenue has been a pub for over fifty years but once it was the site of a nunnery, evidence of which can be seen in the delightful courtyard behind the pub, which is known as the Italian garden. Here you can enjoy your beer and contemplate the statue of the Madonna and the former cloisters around the perimeter of the garden. Mark, the manager of Hove Place, says that he hasn't witnessed any sightings himself, but there have been claims from previous owners that the apparitions of the former inhabitants have been seen moving among the cloisters in their nun's habits, just as they would have when they were alive in medieval times. However, these apparitions were completely benign and behaved as though they were just going about their usual business.

Attempts to discover the name of the nunnery, or convent, have been unsuccessful. However, according to the Jewish website www.jtrails.org.uk, 36 First Avenue was once the home of Chief Rabbi Dr Nathan Adler (1803-1890). Dr Adler was appointed Chief Rabbi in 1845 and wrote his *magnus opus* at the site of the present-day Hove Place in the latter half of the nineteenth century.

Prestonville Arms, Brighton

No one knows what moves boxes and crates around in this pub at 64 Hamilton Road. What's really spooky is that the poltergeist never makes a sound.

The Prince Arthur, Brighton

The Prince Arthur in Dean Street dates from 1860 and is named for the brother of Henry VIII. Prince Arthur died in 1502 at just fifteen years old, leaving a widow, the Spanish Catherine of Aragon, who was later to become Henry VIII's first wife. Henry soon wanted to divorce Catherine to marry the flirtatious Anne Boleyn, who refused to succumb to his ardour unless they married. The result was the separation of the Church of England from Papal authority, the Dissolution of the Monasteries, and Henry establishing himself as the Supreme Head of the Church of England.

John McPherson and Phillip Fifton took over The Prince Arthur three years ago, but now both have become totally freaked out by the spook. This must be one of the most actively haunted pubs in Brighton, although no one has reported a clear sighting of the ghost. However, Phillip says that sometimes, when he is in the pub's kitchen, something 'wafts' past him. It's as though he glimpses something misty of a pale grey colour out of the corner of his eye. Although the haunting exhibits mostly poltergeist qualities, it is a very real presence to both the young men.

Noises are also heard, like items being moved around, and sometimes there are footsteps. Occasionally, when there are several people in the pub, all heads turn simultaneously in the direction of an unexpected noise. Neither John nor Phillip know the origins of the haunting — but they do know there's someone there and wonder if the pub is still occupied by a former landlady. They both feel the presence is a female one.

Eighteen months ago, Phillip had to travel abroad alone for eight days and John was to drive him to the airport. John rose early and made coffee for Phillip, which he placed, as he usually does, on Phillip's desk in the office. When Phillip came down to the bar, John asked if he'd drunk his coffee. 'No, there's no coffee on my desk,' Phillip told him.

John thought Phillip was trying to wind him up. 'Don't play games with me,' he said angrily, not wanting to believe that there was anything supernatural going on. Phillip repeated that he wasn't playing games and there was definitely no coffee on his desk. So John took Phillip to the airport still confused about what had happened to the cup of coffee. If it wasn't there when he returned, he didn't know how he could bear to stay in the pub on his own for eight days — it was simply too terrifying to contemplate.

'I know exactly where I put it', John muttered to himself as he let himself back into the building. He went straight to the office and looked around. And, sure enough, there was Phillip's coffee — but it had been moved onto the mantelpiece.

John also explains how scary it is going down into the cellar, which is dark and gloomy, and another source of strange noises like stuff being moved around. Access is

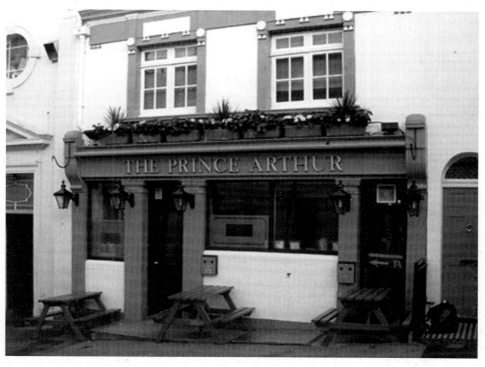

The Prince Arthur — its bright frontage is deceptive. Could this be Brighton's scariest pub? Website photo by permission of John McPherson.

through a flap behind the bar. One day, John could hear a sort of mumbling coming from the cellar, but, on investigation, no one was there.

Phillip reports that orbs frequently appear on the pub's video cameras. 'It's as though we are completely surrounded by orbs,' he says. On 16 July 2009, the day before this report was written, their late shift was just finished and Phillip went upstairs to make himself a sandwich. John followed — and then both of the young men heard a sudden shrill sound from downstairs like someone dropping a knife onto a plate. 'But again, there was no one else down there,' says John. 'We looked at each other and I really didn't want to be on my own.'

The Northern Lights, Brighton

This independent, Scandinavian-style bar at 6 Little East Street is definitely into spirits — those quite apart from the obvious kind. Firstly, as the blurb says on their website, 'The Northern Lights are a force of nature — streams of solar energy spinning into earth's magnetic field — waves of colour arching over the night sky. Our ancestors saw them as dancing spirits. They are a common sight in northern lands... Share the spirit.'

The Northern Lights also has a history to make you shiver. Finnish couple Manu Leppanen and his wife Pale Talvensaari run this bar in Brighton's Lanes. It was formerly known as The Strand. The previous owners of the bar told them how they used to hear their names being whispered to them, and some members of staff were so freaked-out they left. Also, sinister footsteps were heard on the stairs at night, and sometimes a chair creaked just as if someone had sat down on it. 'We've heard the steps,' confirms Manu, who runs The Northern Lights with his wife and the help of his barman, Niklas. But today, none of them are scared by the strange whispers and footsteps. 'The previous owners advised us that the ghost is friendly and we believed them. It only happened on our first night here,' explains Manu. 'I still talk to the ghost when I'm alone here in the middle of the night.'

The Rising Sun, Brighton

The old Rising Sun was in Pool Valley and very close to the beach, so it was a convenient place for smugglers to store their illegal booty away from the prying eyes of the revenue men. Some cynical people claim the following story was invented by the smugglers to prevent people from exploring the cellars, with their massive, begrimed walls, beneath the pub. All the same, it seems such a complex story to have been invented to scare off a few curious locals.

The story appeared in John George Bishop's book *A Peep into the Past*, published by J. G. Bishop (1892). The spectre that haunted The Rising Sun was known as 'Old Strike-a-Light or, sometimes, 'Jack Strike-a-Light'. The legend goes that there was a great storm the night that Swan Jervoise's boat came, despite adverse conditions, safely to shore. It was pitch dark, so captain and crew were amazed to see sudden illuminations burst from all the windows of The Rising Sun. Then they disappeared and all was in darkness again.

Then the phenomenon repeated itself, so Swan Jervoise valiantly set off to find out what was going on. With two of his men, he approached The Rising Sun. There was no one about so the men made a terrific din, knocking and yelling. No one answered but, again, all the windows were suddenly lit up. The amazed men heard a strange sound, like someone striking a light with a flint. Each time they heard this sound, again the lights blazed out of the windows.

The door opened. A huge apparition wrapped in a large black coat with a conical white hat loomed in front of the soaking wet and terrified fishermen, who screamed with terror. This time, the landlord heard them and came down with a light. He invited Swan Jervoise to come inside to warm himself by the fire next to the chimney while he fetched the captain a jug of ale.

As the fisherman warmed his hands at the fire, the rush-light left on the table brightened. Swan Jervoise turned around, and, from the back of the settle, the horrible, pale face of the enormous apparition in the cloak appeared. The ghost pointed towards the hearth. The fisherman was so petrified he screamed and fell unconscious. He was found by the landlord, who took pity on him and put him to bed. Next day, Swan Jervoise told everything to Father Anselm of St Bartholomew, and then he dropped dead.

There was a silver cloud to this grey lining. The hearth, where the apparition had pointed, was investigated and treasure was discovered and appropriated by the Holy

Order. In 1869, The Rising Sun — where fisherman took their fish to be weighed on a large pair of scales — breathed its last and Brill's Baths were built in Pool Valley, much to the scorn of the locals who thought bathing was totally unnecessary and an utter waste of time when there were more important things to do.

Possibly 'Old Strike-a-Light' agrees, as he seems to have disappeared along with the pub. During the first half of the 1700s, The Rising Sun was called The Naked Boy and a sign on the front door depicted a naked child, a roll of cloth under his left arm and a pair of shears in his right hand. 'So fickle is our English nation/I would be clothed if I knew the fashion,' said the sign. Mr Erridge, in his *History of Brighthelmston,* was the writer who claimed to have first connected Old Strike a Light with Swan Jervoise. The Jervoise family was one of the oldest in Brighton and their vault in the old churchyard bears the date 1517. It's said Old Strike a Light was a monk of St Bartholomew's. The Rising Sun, which was at 68 East Street opposite, was lost, along with another old pub called The White Horse, to Brills Bath Co. in 1869.

The Rock Inn, Brighton

The Rock Inn, at 7 Rock Street, Kemp Town, started out as a barn and then became a coach house in 1750. It changed its use into a pub in 1787. In the early days, the cellar was used as a morgue and then, in 1912, it became a temporary Railway booking and parcel office. Reputedly, two ghosts haunt The Rock Inn; one is a female apparition dressed in clothes from the Regency period and the other is the shade of an excise man who was hanged by smugglers in the forty-foot well in the basement of the building, where the felons used to hoard their illicit cargo.

The Rottingdean Club

The Rottingdean Club is a private club, so not somewhere you can visit unless you have first become a member. It was formerly The Olde Place Hotel, and even further back, a row of tiny cottages. Here, according to *Rottingdean, The Story of a Village* by Seaborne M. Moens (1953), a Crimean veteran, known as 'Old Allard', lived in poverty, paying just one shilling a week for the privilege. Everyone, it seemed, had forgotten Old Allard was a hero and the unfortunate man died a pauper.

A famous and charismatic film star is claimed to haunt this grade II listed building. *The Argus* published a report on 22 February 2001 of a change of ownership of the club. And the new owner, Jo Pratt, wasn't in the least fazed by the idea of meeting the ghost of handsome actor, Cary Grant, who died in 1986 aged eighty-two. It's claimed Cary Grant started haunting the building in 1987.

Cary Grant had longed to own The Rottingdean Club because he loved the village of Rottingdean and the atmosphere in the building. His ghost appeared to Mr and Mrs Goodchild who owned the club eighteen months after he died. 'He's not a frightening ghost at all. He's a lovely, warm presence,' said the new proprietor. 'If a place has a ghost you can't get better than the ghost of Cary Grant.'

The club is a Grade II listed building and one of the prettiest in the village, even by Shoreham standards.

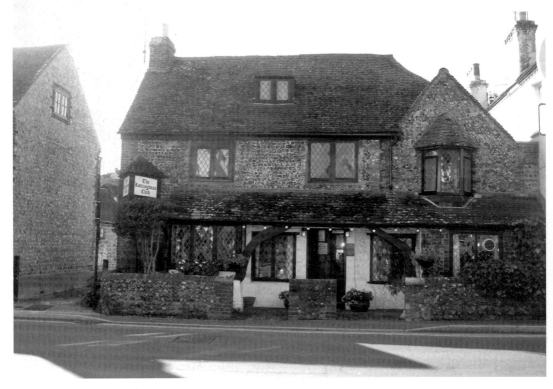

The Rottingdean Club, reputedly haunted by Cary Grant © Janet Cameron

Suters Yard, Shoreham

This corner pub at 1 East Street, Shoreham has been through a number of incarnations; it was once The Schooner, and around 2006 it was The Wood on the Nose. The ghost of a little red-haired girl who was drowned is claimed to haunt the pub and has been seen sitting on the floor in front of the bar and in the lobby to the ladies' toilets. One manager had a young family and one of the children told of a little girl who liked to chat. 'Who is this 'invisible friend?' enquired the parents. 'The little girl in the cellar,' said the child.

There has also been a report of the child giggling and of a large orb (variously reported as blue or white) that floated above the head of the red-haired child. Reportedly, the bottom floor of the pub was once a morgue, where the bodies of drowned fishermen retrieved by the trawlers were kept prior to burial. Footsteps were also heard when there no one around.

Lorna Parker, who now co-runs the pub, says she is aware of the previous ghostly phenomena from the former owners, but since she took over the pub three years ago, there have been no further visitations. So it is hoped the little red-haired girl is now at rest.

The Suters Yard, Shoreham-by-Sea. © Janet Cameron.

The Waterside Inn, Shoreham

You would never guess, just from looking at the exterior of the delightful Waterside Inn in Ferry Road, Shoreham-by-Sea, the bizarre events that occur inside and scare everyone half to death. The inn was previously called The Lady Jane and has lovely views over the River Adur. It's built on a site once occupied by a Carmelite nunnery and this may be the origin of many of the reported apparitions of nuns and monks witnessed by the previous owners. Julie and Dean Lawton have been running the pub for the past six years and although they haven't seen any apparitions — yet — they have some very spooky stories to tell. Both are convinced the pub is definitely still haunted by a poltergeist.

'Often, in the middle of the night, we can hear chairs start scraping and moving about although we know there's no one there,' says Dean Lawton. 'But that's not the only thing.' Several tunnels run from the pub, and the all entrances are still *insitu*, mostly consisting of smallish, square openings behind doors hatches and set a few feet above the floor level. An average-sized person could just squeeze through, although it's hard to imagine who would want to venture into that dark, spooky place. Two of the tunnels (those shown in the photographs) once went under the river to The Ferry Inn on the opposite bank, and these were used by smugglers. Most of the longer tunnels have now been 'back-filled'. It seems these gloomy labyrinths may be the source of the spooky goings-on in the huge cellars below the inn. Julie and Dean also have their office in the cellars, so they have to spend some time down there and learn to live with these unpredictable spirits.

'The cellars are very warm,' says Julie, 'but on several occasions we have been in the office and the temperature suddenly changes from warm to icy cold. It only lasts for ten to fifteen seconds, but it seems to come from nowhere, and it makes the hairs stand up on the back of your neck, as though something horrible has just passed over your grave.' Frequently, Julie and Dean find the beer in the pub has unaccountably gone flat, and when they go to the cellar to investigate, they find that the gas has been turned off. This has happened at least eight or nine times and there seems to be no other explanation but the supernatural.

'We asked the staff if they were responsible, but they firmly said "No". Anyway, staff are not allowed to go into the cellars for health and safety reasons,' says Dean. The couple's two dogs are used to running up and down the stairs in the pub, but they refuse to go down the cellar steps, sensing there's something not quite right down below. On one occasion, it seemed as though the poltergeist decided to leave its regular haunt in the cellar to have a look around upstairs. This was around eight months ago when Julie's father was in the living room on the upper floor with their white German Shepherd. Her father was looking at a picture he'd just put up to make sure it was straight. 'Suddenly the dog backed up and started growling. Its hackles rose and then it went absolutely ballistic, as though something else was there,' says Julie. 'Dogs are very tuned in to these things, much more than people and I'm sure they sense things that we cannot.' So perhaps the apparition is still around, but now only visible to the dogs. It's generally believed that apparitions begin to fade with time, so it does make perfect sense that the dogs might see what the humans cannot.

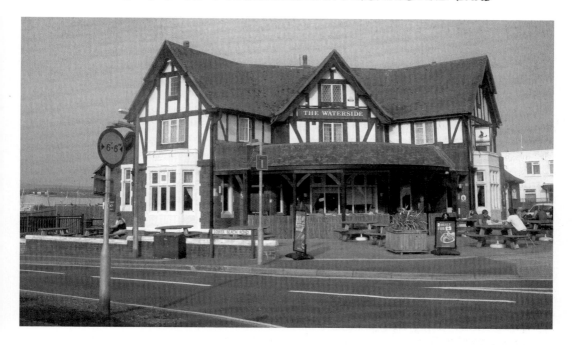

Above: The Waterside Inn. © Janet Cameron.

Right: The stairs down to the cellar, which terrify the pub's two dogs. © Janet Cameron.

One of the tunnel entrances. © Janet Cameron.

Dean uncovering one of The Waterside Inn's tunnels. © Janet Cameron.

The Oldest Inn in Brighton

According to a report in *The Argus* dated 3 January 1952, a Mr Ernest Trory had tried to find out the oldest inn in Brighton. After studying Cobby's *Brighthelmston Directory of 1799*, he decided one of the oldest is The Cricketers of Black Lion Street, formerly known as The Laste and Fish Cart and generally believed to date back to 1545. He said The Cricketers was not as old as The Greyhound (formerly The Anchor) and The Old Ship, both in East Street. Mr J. G. Bishop, a nineteenth-century historian, had no doubt that The Old Ship was the oldest inn in the town, as asserted in his book *A Peep into the Past*.

UNINVITED GUESTS IN BRIGHTON HOTELS

Brighton hotels also have their fair share of ghostly guests, some of which are pretty spectacular. This first account is of the haunting of The Marlborough Hotel, which is the site of one of the most notorious and grisly murders in Brighton's criminal history.

The Marlborough Hotel

Ghostly activity at The Marlborough Hotel in Princes Street is so intense that it received a visit from the Paranormal Society. One of the visitors, a psychic, said she could see the apparition of a woman in a black dress and wearing jet-black beads. This was thought to be the ghost of Lucy Packham, according to a report in *The Argus* dated Monday 30 October 2000 and describing the brutal murder of the young woman by her husband in a fit of rage.

Thomas Packham, the publican at The Marlborough Hotel, was a thug and was violent to his wife and children. On 2 March 1900, a Dr Ross was called to The Marlborough Hotel to find Lucy Packham dead. Lucy Packham, the daughter of a butcher, had married Thomas Packham in 1888, and the couple had three children. The cause of the death was found to be serious bruising to the head and body, and, as confirmed by the post mortem, cerebral haemorrhage.

Thomas Packham was charged with murder, and witnesses gave evidence of his brutality and verbal abuse towards his wife, for example he had once even hit her with a heavy stewpot. It was reported how he had flung her into a seven-foot deep, grave-like pit before he ended her life. The jury was composed entirely of men and after Thomas Packham reported how 'dirty and idle' his dead wife was, he was found guilty of manslaughter instead of murder. He received four years' imprisonment and reportedly served only three, a paltry punishment for his crime.

Lucy was just thirty-two years old (thirty-six in other reports) and it is no wonder the poor woman still cannot rest. Many customers claim to have felt Lucy Packham's presence and witnessed the activity of the poltergeist she has left behind her. The manager, Sue Kerslake, detailed these activities as playing around with lights and switching of the gas on the beer taps. The poltergeist of Lucy also sweeps bottles off a shelf behind the bar and twirls lampshades. The landlady often has a strong feeling of being watched. 'I've never seen her properly,' she said, 'just fleeting glimpses when I've

been on my own. When I thought about it, as she was beaten to death by her husband, she probably didn't like men too much. She is more comfortable with female company. It's not scary because she isn't nasty and she's been here a lot longer than me anyway.'

Sue Kerslake always warns new members of staff about the haunting and, although no one has yet declined employment, most are too terrified to enter the cellar. One employee, Paula, of St James's Street, didn't believe in ghosts until she began working at The Marlborough Hotel in 1998. 'I've known Sue for a long time,' she said, 'and she's not the sort of person to make things up. Sometimes you do feel there's someone in the bar with you, even if you can't see anyone else is there.'

Originally, The Marlborough Hotel was known as The Golden Cross Inn and was formerly a coach house. It was renamed The Marlborough Hotel and Theatre in 1850 and was once owned by Henry Witch who died in 1806.

The Regency Hotel, Brighton

The Regency Hotel, it is claimed, is haunted by a disabled girl, and it is thought her ghost dates from 100 years ago and that her father was a cobbler. The family lived on the premises, upstairs. Apparently, when the cobbler installed gas, he was most concerned about gas leaks. Perhaps the child disregarded his strict instructions and was shut up in her room for her disobedience. She became frightened, believing she could smell gas escaping, and tried to climb out of the window. Tragically, she lost her balance and plummeted to her death. Reports also claim her ghost still flings itself from the area of the now bricked-up first floor window and then vanishes.

Since poltergeists often manifest themselves around areas involving children, this young girl may be responsible for glasses and furniture moving around on the property. However, former occupants of a building are often unhappy about the new insurgents on their territory, so maybe it's a previous landlady who doesn't know she's dead and who is responsible for the displacing of objects. This grey lady is said to be tall, very slim and grey-haired and is in the habit of floating through walls. Some people claim she dates from the 1930s, while others say she's a Victorian.

Royal Albion Hotel, Brighton

Some people believe that a ghost spotted in the Royal Albion Hotel might be that of Sir Harry Preston, businessman and philanthropist, who was born in 1860. Sir Harry's ghost prefers to hang out near the Sir Harry Preston Function Room. Doors mysteriously open and close, apparently by themselves, and there are sometimes very chilly and unexplained draughts. It's also claimed that the lift has been known to ascend and descend when there's no one around to operate it. Apparently, the ghost of Sir Harry prefers make himself visible mostly on Sunday evenings and he's easy to identify because he's always wearing his smart bowler hat.

Sir Harry Preston (1860-1938) bought the Royal Albion Hotel in 1913, after it had been closed for around thirteen years and he entertained many famous people there, including the Prince of Wales. He was knighted for his support of charities and sports in 1933.

CHAPTER 4

THE RETAIL SPECTRES

Some people believe that ghosts, apparitions and poltergeists are most likely to be experienced in the very oldest buildings. The opposite is true. Apparitions and paranormal manifestations are connected to a site or a location, not a building, and hauntings can occur in new modern developments in an area where something traumatic or sinister took place. This explains why ghosts can pass through walls — simply, the wall wasn't there during their physical time on earth. Similarly, they appear to ascend or descend stairs no longer in existence, or move above the ground or floor — at the previous floor or ground level.

The above may not be true of poltergeists, some of which seem to attach themselves to particular people — and follow them if they move to a new place.

Ghost of a Murdered Wife

This shop is no longer in existence, but it's reported that a bric-a-brac and junk emporium in Upper Rock Gardens, Brighton, was the site of a horrific murder of a wife by her husband, who was believed to have become insane. This is a very unpleasant ghost, since it is naked and disfigured from the attack on the earthly plane. The murder dates from around the 1950s.

A Strange Apparition at The Sussex Book Shop

Two members of staff at The Sussex Book Shop in the centre of Brighton's Lanes had a scary experience one night in the 1950s when they were working late pricing up diaries on the upper floor. One of the ladies left an invoice on the ground floor, so she went downstairs to retrieve it. The other lady continued with her task of pricing up, when she heard footsteps coming back up the stairs. Glancing up and expecting to see her colleague, she was horrified to be confronted by a figure in a monk's or maybe a nun's clothing, but the great cowl hood contained nothing, just a blank space. The terrified ladies never worked late at The Sussex Book Shop again.

Ghostly energy can gradually deteriorate over time, so that apparitions can become less substantial, just a ghost of a ghost — hence the lack of a face inside the cowl hood.

The shop was in East Street just by the twitten leading to Little East Street. It's now a dress shop.

Extra Help from Beyond the Grave

In St James' Street in Kemp Town, there used to be a café above Hilton's Shoe Shop called The Zodiac Coffee Bar. Geraldine Curran used to go there with her school friends. She also attended parapsychology classes in the seventies, and there she met a woman who had worked there in the forties/fifties. At that time it was a tea-room. The woman arrived for work on a Sunday and in the kitchen there was a figure standing by the sink, washing up. The woman was surprised because had never seen the 'person' before, so she thought it must be a new employee, although she did think it was a little strange that the figure was wearing a long skirt. Later, when another waitress arrived, the woman asked: 'Who was that woman washing up in the kitchen?'

'Oh,' said her colleague, 'so you've seen the ghost. Don't worry about her, she's harmless.'

Where's the Shampoo?

A hairdressers, just a few doors away from the café above and near the Queens Arms, also experienced some paranormal activity but of a less helpful kind. For a start, it always made the premises so cold, and whenever the employees arrived in the morning, there would be a disgraceful mess to clear up. Shampoos and other hairdressing equipment would be strewn about all over the floors and chairs, from the previous night's poltergeist activity. The shop is still a hairdresser's, but now it's a men's salon.

An Angry Spectre

An article in *The Argus* dated 6 July 2002 tells the scary experience of an antique shop manager, Derek Wallace, aged forty-seven, whose building was due to be bulldozed. Derek Wallace managed Clocktower Antiques on Queens Road, Brighton, for twelve years, but the owner wanted to replace it with a new shop and flats and had applied for planning permission.

The cellar under the shop had been a secret drinking den and the site had also once been occupied by a money-lender. It was claimed that there had been spiritual activity there before, but in the last few months it had increased dramatically. One lady had approached Derek to say her mother had gone into the shop and seen an old man standing on the stairs. To her amazement, he suddenly disappeared, leaving her disorientated and shaking. The previous week Derek also saw a figure on the stairs. 'It was wearing a big cloak and I could hear it moving around. I saw it for a few seconds but then it was as if I startled it and it disappeared.' Anxiously, Derek checked the upstairs rooms. Then he shouted to his colleagues. One said, 'You look like you've seen a ghost!'

A former sceptic, Mr Wallace said he was now converted into believing in the supernatural world and felt that the apparition he saw objected to the destruction of its

favourite haunt. To make its feelings known, it had decided to make itself visible. Now, every time Mr Wallace walked upstairs alone, his hair stood on end.

The spectre had some ghostly company. A shadowy figure had been seen at an upstairs window and strange noises had been heard. A lady who ran the sandwich bar next door confirmed she'd heard furniture moving overhead and sent her husband to see if there was an intruder, but there was no one there. She said this had been going on for fourteen years. 'Derek has always pooh-poohed the idea,' she said, 'until he saw something that put the wind up him.'

PERSONAL PARANORMAL STORIES FROM LOCAL PEOPLE

It's amazing how many private houses and flats in the 'cauldron' of Brighton and Hove and its surrounding villages are haunted, and how many people in the area possess psychic abilities. Some people, although entirely sincere in their paranormal beliefs, prefer not to be identified so their names have been omitted.

Psychic Cats

One woman reported buying a house in Brighton that dated from the late 1800s. A previous owner had died in the house and it was almost uninhabitable, so the woman and her husband set about renovating it. But it seems the ghost of the previous owner wasn't happy with the alterations, because the woman was woken up one night by a sudden icy chill, a common sign of an unwanted manifestation.

When a friend visited one day, he went up to the bathroom, and suddenly rushed back downstairs and said he had to leave because he had seen a ghost upstairs floating across the landing. The same woman had several cats. These were strays that she had rescued, and she says that the cats would simultaneously turn to stare at a certain part of the room, then turn away again. Animals are, of course, extremely sensitive to spirit vibrations, but the entity was obviously not malevolent or the cats would have run away, instead of just turning their heads.

A similar story is told by a lady who lives in a flat in Adelaide Crescent with her two Persian cats. She feels there is a benevolent spirit in her home, and when it passes all three of them feel the draught, and as her head turns towards the presence, so do the heads of the two cats.

A Sweet Tooth

A small boy called Arthur, who lived in a haunted three-storey house in Richmond Road in the early seventies, was crazy for sweet things. His bedroom was in the basement of the house and his Uncle Frank slept in one of the two bedrooms on the top floor. On the middle floor Uncle Frank kept special sweets in a tin for Arthur as a reward for when he was good.

One night, Arthur couldn't sleep because he just couldn't stop thinking about those yummy sweets in the tin upstairs. Eventually, the temptation was too great, and the ten-year-old got out of bed, ever so quietly so no one would hear him, and made his way to the foot of the stairs so he could sneak up to the floor above to nab himself a tasty treat. As he put a foot on the first stair, something came swiftly towards him. Arthur turned and fled back into his bedroom, jumped into bed and, shivering in terror, shut his eyes tight and pulled the blankets over his face.

He tells the story as a fully-grown man and finds it difficult to describe the apparition. It had simply moved too fast, so it was little more than a blur rushing towards him. However, Uncle Frank had also had a paranormal experience in the very same house, this time in his bedroom on the top floor. He woke up one night and saw a ghostly apparition sitting on the chest of drawers. Arthur was unable to describe it and Frank wasn't available for comment, but it does seem that house was haunted by something strange and very fast moving — at least, when it wasn't lazing around on the furniture.

A Pretty Girl with a Parasol

A strange story appeared in *The Argus* dated 20 May 2009. A woman, Mrs J. Heart of Coldean, wrote to the paper about the time she lived at 52 Mighell Street in the Second World War. She said that the part of Mighell Street where she lived is now the site of the American Express building.

At the time of the sighting, her father was away on business, so her mother, her younger sister and she shared the large bed to keep warm. They were lying there together one night, when the ghost of a young woman in a long gown and holding a parasol appeared from the right-hand side of their bedroom, floated right in front of their eyes at the front of the bed and vanished into a wardrobe on the opposite side of the room. This was a one-off event, and Mrs Heart didn't know the provenance of this strange occurrence. However, she remarked that their house was in a small alley, at the end of which was a spiritualist church.

Maybe someone from the church had conjured up the spirit and it was simply on its way to the meeting. Some things we will never know!

The Flat in Lansdowne Place

George is convinced his flat is haunted. When he bought the flat from an old lady twenty-five years ago things 'started to go bump in the night'. This old lady, a Miss R., was about to go into a nursing home. She told George that the flat would be no good for him and was most unwelcoming. The flat was in a poor state of repair, and Miss R. said that a builder should buy it. She emphasised it would be a big mistake if George bought it. She was not a friendly old lady, in fact, the opposite.

When George eventually moved into the flat and started to do repairs and redecorations, things started to happen. He moved into the bedroom and experienced loud knocking on the wall in the corner of the room. This knocking started at 10 p.m. and went on all night until the next morning, preventing George from getting a good

night's sleep. He contacted the Council to see if they could assist and also the neighbours, but without success. It's well known that ghosts do not like alterations to 'their' homes. Friends came to visit and they too heard the knocking. It was obviously not pipes or a washing machine, as no washing machine would operate all night, every night.

This went on for about two years and gradually stopped. One day a friend, who was psychic, came to stay and he was alarmed, saying he could hear deep breathing. The flat did feel as if there was a curse on it, as so many things went wrong and George incurred heavy expenses. There are also cold spots in the flat despite central heating and hot weather.

Then, in October 1999, his sister, to whom he was close, died suddenly. This caused him much distress, and more strange things started to happen. Jewellery and a pair of gloves he had bought in Venice that Christmas disappeared. He hunted throughout the flat and made enquiries from friends, with no luck. At night he felt a cool breeze on his cheek as if he had left a window open, but he realised he hadn't. He felt it was the spirit of his sister to reassure him that there was an afterlife. A friend phoned and he told her about the loss of his jewellery and she said it was probably his sister, as she'd heard of several people who had put down items in their usual place and then went to pick them up only to discover they had disappeared. She told him to call out loud to his sister, 'Kate, have you taken my jewellery?'

This was on a Saturday, around mid-day. So George did what his friend suggested and then finished the call. He went to Waitrose to do his shopping, and returned at two o'clock to receive another phone call from a friend, Steve, who asked why he had phoned him. He said there was a message that was difficult to hear on his answerphone. It sounded faint, as if it was from abroad. George said he hadn't phoned Steve as he'd been out at the time. Steve insisted he had, as the phone number was recorded on his phone. Around the same time George's nephew also had strange messages on his answerphone from a female. One of his friends had phoned him, and a woman's voice said he was not at home. Could this, thought George, be his sister getting up to mischievous tricks, this time targeting the nephew?

On George's birthday in July the following year, he was going out to celebrate with Steve, when for some reason he felt an urge to look in the meter cupboard by his front door. And there were his gloves! Yet over the previous year, he'd been to his meter cupboard and the gloves were not there. Unfortunately, he has still not recovered his jewellery.

A few years later, George and a friend went to see a medium who was appearing in Eastbourne. They thought it was a most interesting evening. When George got home and sat down to watch television, suddenly his collection of fob watches started to rattle in the display cabinet. At first, he thought he had imagined it, but it happened twice more. This had never occurred before. He thought it must be his sister Kate trying to contact him again, and he felt reassured.

Recently, other weird things had happened. George had a pasta jar that was on shelving on the kitchen wall. One day, he tipped out the remains of the spaghetti, intending to buy more from the supermarket, and then he placed the empty jar back on the shelf. Next time he went to get the jar to fill it, it wasn't there. He knew he hadn't broken it, and it was too big to accidentally throw into the rubbish bin. Two weeks passed, and he resented having to buy a new one, but eventually found another in a charity shop. Then, some days later, he found the original jar. It was on the other side of the kitchen in a cupboard rarely used.

'I definitely didn't put it there,' he says. 'It *always* went on that top shelf on the other side of the kitchen.'

George's sister had been quite a lively and mischievous person, and he believes his sister is playing tricks on him, just to let him know she's still around. He says he finds it very comforting that there is 'another life' in his flat. He feels close to her children and he believes it is his duty to be there for them. He has a friend who lives in Cambridge Road who also had a brother who died. This brother had been a difficult character in his life, 'burning the candle at both ends'. Ever since his death, there has been poltergeist activity in his flat. George's friend just calls out to his brother to stop it. The friend's deceased brother has a daughter, so perhaps the spirit is worried about her wellbeing and wants to ensure that her uncle is looking after her.

NUNS AND MONKS HAUNT THE LANES' ANCIENT TWITTENS

The layout of The Lanes in Brighton's Old Town still survive in their original format from the eleventh century. Originally, they were the site of the little fishing settlement of Brighthelmstone. They were burned down by the French in 1514, but once was enough for all those who loved Brighton. So when the French tried it again in 1545, the alarm was raised and plucky Englishmen from all surrounding areas descended on The Lanes and fought off the foolhardy French. Today The Lanes are an enchanting labyrinth of delightful shops, pubs and inns, bustling with bohemian activity, and many of them with a spooky story to tell.

The Medieval Monk

A medieval monk is said to drift along Black Lion Lane, one of the Old Town's most interesting twittens, and disappear through an old arched stone wall. Some people believe the monk was bricked up inside as a punishment for having an affair with a young girl. It's also been said that this is unlikely because the wall is only 200 years old so, clearly, the medieval monk couldn't be bricked up in there. Nevertheless, ghosts walk through walls and doors and appear to climb stairs that aren't there, so maybe he was bricked up in an even older wall that no longer exists but was replaced some time later.

Dying for Love

Another account claims the ghost of a nun haunts the area. It's said that in the twelfth century, a priory stood here, St Bartholomew's, and soldiers were ordered to guard the building to protect the nuns from the local ruffians. A nun and a soldier, who had been assigned to guard duty, feel in love and began an affair, and they decided to run away together. Unfortunately for them, they were captured by the young man's fellow soldiers and the soldier was executed.

The nun was bricked up alive in the wall and abandoned to starve to death, and it can be assumed this was carried out by holy orders. It was a usual practice to brick people up to avoid bloodshed, which was against religious convictions. It's hard to imagine

Beware of the apparition of a tormented nun in this spooky narrow lane, Gareth Cameron ©.

how it's less sinful to leave someone bricked up alive to suffocate slowly to death than to arrange a quick execution. It must have been little consolation to the poor young woman that, as she suffered, the other nuns were praying for her soul.

The nun's ghost is also said to walk through this 200-year-old wall, but again, maybe, as before, the wall replaced another wall considerably older, or it could have been a different wall in a different place and the route followed by the ghost has some other explanation.

PARANORMAL ACTIVITY AT THE ROYAL PAVILION AND OLD STEINE

Between the Pavilion and the Dome there's an underground tunnel once used by the Prince Regent (1762-1830) who ascended the throne in 1820 after the death of his father, the so-called Mad King George III, who suffered from 'porphyria', a horrible disease of the nervous system.

At that time, the present-day Dome was the site of the stables. The Prince Regent, or 'Prinny' as he was affectionately called, was becoming overweight at more than seventeen stone and was subsequently less mobile. He didn't want people to see his ungainly figure struggling across the Pavilion grounds to the stables, and so he used the special tunnel to get to his horses. Nowadays, the tunnel is only used for maintenance purposes, but one day one of the Pavilion staff was checking out the tunnel, when the ghost of the Prince Regent appeared right in front of him. This gadabout ghost has also been spotted in the tunnel between the old cellars to The Druid's Head.

Another account related by local historian, Geraldine Curran, tells of a conversation she had with Dr Derek Rogers, Keeper of Art at the Royal Pavilion. Dr Rogers told her that he had seen the ghost of a servant coming down the hidden staircase behind the bed in the King's Apartment. George IV suffered from insomnia and several other illnesses. As he was unable to sleep, he called continuously for his servant to give him something to help him. His servants' rooms were above his own bedroom, and it was obviously on one of his many trips that this spooky impression was left in the ether.

Although the Prince's favourite lady was Mrs Fitzherbert, he had a few other ladies in tow, just for variety, including a lady called Martha Gunn. Apparently she was a large lady who wore big flowing dresses and floppy hats. One day a member of staff was checking the rooms, including this former banqueting hall. He was amazed as he entered the room to see a lady in period dress, walking around the banqueting table, checking all the place settings.

He reported it, believing it to be an apparition, since no one but him was on duty that night. On being shown a picture of Martha Gunn, he recognised immediately the lady he'd observed moving around the banqueting table. Martha Gunn's grave can be found at St Nicholas' church in Church Street. She was famous for being one of Brighton's most successful 'dippers' — these dippers helped people to bathe in the sea, using horse-drawn bathing machines. Martha Gunn was particularly skilled at this, being of a strong, sturdy constitution.

Many people believe there's a tunnel running from the Pavilion to Brunswick, used by the Prince to visit his paramour, Mrs Fitzherbert, but this, it is claimed, is a fallacy and there is no such tunnel.

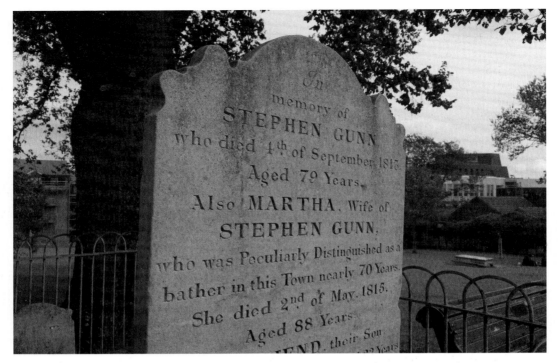

Martha Gunn's tombstone. © Gareth Cameron.

The conservation area, where all the renovations are done, was once used as a hospital. Dean Page, who is a security guard at the Pavilion, reports that he has 'very strange feelings' when he's in that area. These are not negative or scary feelings. Dean believes that he is looking after the place and the ghosts know that, but, just to be on the safe side, he always says, 'Good morning' when he enters the workshop.

Phantom footsteps have been heard in the Pavilion Fine Arts Gallery — but there is never anyone there. There is, however, a picture of King George IV, who, it is claimed, also haunts the art gallery area. Dean sensibly says 'Good morning' to the King's portrait, and so far the vibes have remained benign. On another occasion, one of the staff was in the King's Apartments and he went to open the shutters and saw a phantom cavalry boot right next to the shutters.

One particularly gruesome account tells of a lady sitting on a bench and waiting for her husband in the Pavilion Gardens. She dropped her arm over the back of the bench and felt her fingers sink into something *gungey*. Looking back, she was horrified to see her fingers in the maggot-infested eye-sockets of a horribly decomposing corpse. It seems possible this story might have a connection to the claim of an apparition of a horrifically mutilated man who wanders around Old Steine.

There is a particularly grisly legend behind this claim. Some people have identified the phantom as that of John Robinson who lived in the eighteenth century. He was a mercenary in the Middle East during a civil war, and he supported a rebellion that was suppressed. As a result, he was captured, tortured and suffered an horrific fate — like about 20,000 others, his eyes were put out with hot irons and he was reduced to

begging on the streets. Seeing him in this pitiful state, a kind English merchant helped John Robinson to get back to Brighton. But, with a shocked crowd around him, he lay down and died of his injuries in the Old Steine area. It's claimed that one day a policeman became very sick after seeing John Robinson's phantom lying in the road, its eyes gouged out to the bone and the ghost maggots still eating his flesh. Another woman unfortunate enough to see this horrible apparition had to be hospitalised overnight. There is a much-repeated local rhyme about the tortured mercenary soldier:

Don't ye dally, darling dear, in Brighton's city clear,
The ghost of old John Robinson is waiting for ye there.
If ye look into his face, you'll end your days that night.
For he'll steal your eyes from you to give a beggar sight.

So, be warned!

The Pavilion Pussies

The following stories aren't *especially* ghostly, but they might provide a touching antidote to the above gory story.

George Reincarnated — an Obituary

According to the *Brighton and Hove Gazette* dated 26 July 1980, George the Pavilion Cat had met his end tragically suffering from rheumatism and another unnamed ailment that caused the Pavilion carpets to become spoiled. George had been named after George IV because he had white fur down his front legs that looked exactly like garters, and staff thought he might be a reincarnation of the King. He was laid to rest in a basket marked 'George his basket' and a proper funeral was held with members of staff present. George had been on the payroll, earning 25p a week, later increasing to £1 (due to inflation) and this payment was redeemed in cat food. His duties were mousing, amusing the visitors and publicity, so it seems George was severely underpaid!

Peter and Tatters

Close to George's grave are two more little graves and these are their epitaphs:

Here lies dear Peter who was cross and sulky but loved us, December 1880.

Here lies Tatters, Not that it much matters.

No date is recorded for Tatters, but maybe he wasn't important enough, not being a reincarnation of anybody of particular note.

CHAPTER 8

POLICE MATTERS OF THE PARANORMAL KIND

According to *The Argus* dated 3 May 2005, in the year 1812 before the birth of the proper police force, there were eight watchmen whose purpose was to keep the town safe. They wore a top hat, a black tailcoat, white trousers and carried a baton and a rattle. In 1838, there were 31 police officers in the local police force for a population of 47,000. This consisted of a chief constable, two superintendents, three inspectors, twenty-four constables and a night constable. At this time policemen wore top hats, but in 1868 the helmet became the preferred headgear. By this time there were 100 men. By 1901, this had increased to 150 officers for a population of almost 124,000 people.

In 1967, 424 officers policed 169,000 people and it was at this time Brighton Police Force was amalgamated into the Sussex Police Force.

The Troubled Ghost of Brighton's Chief Constable

Henry Solomon died on 14 March 1844, and he is believed to be the only chief constable in the UK to have been murdered in his own police station. A Jewish man, he became chief constable in 1838.

On 13 March 1844, the day before that fateful day when the Chief Constable met his death, John Lawrence, aged twenty-three, was loitering in St James' Street in central Brighton with another young man. This was an opportunist crime. The two of them grabbed a roll of carpet from a shop and made off with it. The other man escaped but Lawrence was captured and arrested and taken to the police station at the town hall.

Later, John Lawrence was interviewed by Police Superintendent Henry Solomon at the police station, but because he was in a state of agitation, questioning him was proving difficult. Henry Solomon persuaded the young felon to sit down by the fire to compose himself. Although there were three other officers in the room, they were not alert enough to prevent him from going to the open fire and seizing the red-hot poker.

Lawrence swung the poker as hard as he could to the side of the policeman's head. The wound was fatal and although Henry Solomon was not killed immediately, he died later of his wounds. It is recorded that the blow was so heavy that the red-hot poker was bent. John Lawrence was charged and found guilty at Lewes Assize Court and execution was set for 6 April 1844, outside Horsham prison on at twelve noon. This was Horsham's last public execution.

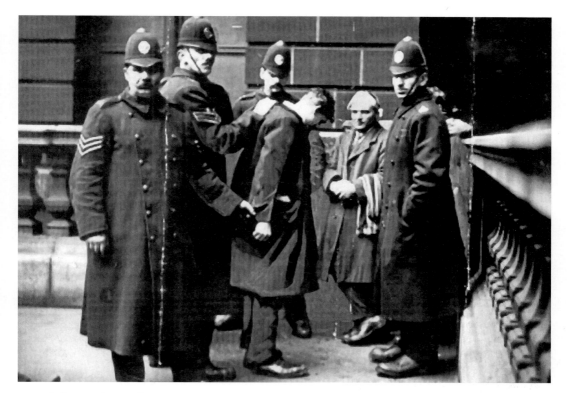

Policemen in trenchcoats, 1919.

Henry Solomon is buried in Brighton's Old Jewish Burial Ground in Florence Place. He left a widow and nine children. The inscription on his gravestone reads '15 years chief officer of police of the town of Brighton| who was brutally murdered while in the public discharge of the duties of his office|on the 14th day of March 1844 in the fiftieth year of his age.' It is claimed his ghost still haunts the former premises of the old police station in the basement of the town hall.

According to a report in *The Argus* dated Friday 7 September 2001, one man, George Vane, who had worked at Brighton Town Hall for over twenty years, told how he, and another man, Danny, had felt a presence in the basement. 'All the hairs went up on the back of my neck a couple of times. Sometimes I have to go down there in the middle of the night, but it doesn't bother me. There is not a bad feeling and nothing has ever been thrown about.'

Members of the public were to be invited into the old police cells that coming weekend said *The Argus* of 7 September 2001, thanks to the Open Door Event organised by the Regency Town House charity. When they were in use, the facilities in the police cells were extremely basic, there was a public cell, its floor covered in straw for the drunks to dry out. All the cells had heavy wooden doors with spy holes for the officers to keep watch on prisoners. There are marks where prisoners scratched their names onto the walls.

In addition to Henry Solomon's basement haunting, other paranormal activity has been claimed in the upper building of the town hall, including a monk, dating from

when a monastery stood on the site. The monk was in exile from the monastery for a misdemeanour and it's claimed he returned to ask for forgiveness and then was trapped in a fire in which he died.

Psychic Law

A policeman from Woodingdean who was a pupil at Brighton's Queen's Park School, used the supernatural to help him solve crimes, according to an article in *The Argus* on 9 February 2000. After thirty years in the Metropolitan Police, Keith Charles, the policeman, retired and decided to use his psychic skills to act as a consultant for Scotland Yard.

Keith first discovered his psychic powers when he was seven years old (or eight years, according another source). His small cousin went missing while swimming at Black Rock pool but Keith tuned in and was able to locate the little boy, and so the child was saved from drowning. In 1968, his grandfather died. Later, his ghost appeared to Keith who was very frightened, but he now knew without a doubt that he was different from other people, that he had special gifts. Also, he began to believe that there was life after death.

Once Keith was staying in a house when he heard footsteps coming upstairs. To his amazement, three women walked in wearing puritan-style dresses and then promptly walked through the wall. Keith's conviction that he possessed a supernatural gift was subsequently confirmed by a medium. The ex-policeman went on to develop his skills through classes at a Spiritualist church. 'When I help someone who has lost somebody, it makes it all worthwhile,' he said.

Three years later, on 13 August, *The Argus* reported that the psychic policeman was displaying his talents at Worthing Pavilion on 2 September. Keith Charles told the paper he knew the whereabouts of Lord Lucan and that he was in regular contact with his own dead son. He was also to appear on the Discovery Channel on 23 August in a programme entitled 'The Ultimate Psychic Challenge'. 'He is now among the most successful mediums in the UK,' said the report in *The Argus*.

SUPERNATURAL STORIES OF ROTTINGDEAN, SEAFORD AND NEWHAVEN

The coastal towns of Rottingdean, Seaford and Newhaven lie to the east of Brighton, just a short bus-ride away, and they have some very interesting old houses — as well as ghosts! Rudyard Kipling moved to Rottingdean in 1897 and remained until about 1903. This part of the coast was a smuggling haven, and Rottingdean's old smock windmill was once used by smugglers to signal to their accomplices. The Grange at Rottingdean, see below, is well worth a visit, with its delightful museum progressing back through the ages to prehistoric times.

The Black Prince's Rottingdean Residence

Probably Rottingdean's most famous ghost is that of Edward, Prince of Wales, also known as The Black Prince. Edward never got to be king, since he died before his father, Edward II, and the throne passed to his son, Richard. Perhaps Edward felt cheated and that's why his ghost, as it is claimed, continues to haunt The Grange, a fine Georgian building dating from the 1700s. Alternatively, as others believe, the haunting may occur because of a terrible tragedy visited upon Rottingdean.

The Black Prince was alleged to have stayed at The Grange in 1355. He got his nickname because he was ordered by his father to wear a black cuirass to fight the Battle of Crécy on 26 August 1346. He lived up to his name, as he was a fine fighting soldier who was feared by the French for his valour on the battlefield. Some people think Edward started haunting The Grange because, a year after he died in 1377, the French Navy invaded and lay siege to Rottingdean, setting fire to the village. Villagers took refuge in the church but the cruel French invaders set fire to it and all of the villagers inside perished. Also, a number of Edward's best friends and favourite comrades-in-arms were captured for ransom. There have been a number of sightings claimed of this valiant fourteenth-century icon of the Hundred Years War, who, in his lifetime, became the scourge of the French threat.

The Grange was a vicarage during the time it was occupied by the Revd. Doctor Hooker, who ran a school there. He was vicar of the parish from 1792 to 1838, according to Seaborne M. Moens in his book, *Rottingdean, The Story of a Village* (1953). Mr Moens records that the wily Reverend was not averse to shady dealings to line his own pocket; he also acted as accomplice and lookout for the village smugglers.

Above: Rear of The Grange, which is now a museum, library and tea garden. © Janet Cameron.

Left: Edward, the Black Prince.

A Sad Little Boy at Seaford

A sad boy ghost is claimed to haunt a fine building called Corsica Hall, which was built in 1824, replacing a much older building of the same name. It was this older version in which the tragic accident that caused the haunting took place, but at the time it wasn't actually in Seaford. The house has a complicated history.

According to a report in the *Sunday Express* by Kevin Gordon, dated 17 April 2009, the original building had been built at Wellingham near Lewes in the 1740s by a man called Whitfield, who had become rich smuggling Corsican wines. It was when he died that the fifth Lord Napier, Francis Scott, purchased the building so he could bring his family to Sussex away from the hostile Scottish winter.

In May 1772, Lord Napier's son was being tutored, but a pistol had been left in the study. The little boy picked it up, pointing it at the tutor and joking, 'Shall I shoot you?' The tutor joined in the joke and encouraged the child to shoot the gun, unaware it would be loaded. The boy pulled the trigger and accidentally shot the tutor dead. Naturally, this was a shock for the entire family and so they moved away. Since then, the house was claimed to be haunted by the ghost of the sad little boy who was made so miserable that it seems he never got over the guilt, even after death. In another version of the story, it's claimed the victim was a chaplain, although it's possible this may also be correct, as a chaplain may have taken on the tutoring of Lord Napier's son.

After this horrific event, a Lewes watchmaker, Thomas Harben, purchased the house and moved it brick-by-brick to Seaford. In 1823, John Purcell Fitzgerald demolished the old building and built the fine new house that exists today. Reports of the haunting of both the boy and the tutor continued for a while. Historian Geraldine Curran, who once worked for UNISON, says the training officer told her about the ghostly appearances. When he held weekly training courses at the site, his students had complained.

As Kevin Gordon points out, these would have to be very resilient ghosts to persist after the wholesale removal of the old house, its demolition and the erection of a new one.

The Vanishing Car

Also reported in the *Sunday Express* in Kevin Gordon's article was a sighting in October 1976 by two people walking along Seaford's esplanade at dusk. An old car veered out of control and crashed into the sea wall — but instead of an enormous bang and a pile of wreckage, it simply passed right through the wall. Amazed, the couple ran to the scene, but the old car and its ghostly occupants had disappeared.

The Ghosts of the Mutinous Soldiers

A further account by Kevin Gordon of the *Sunday Express*, which was taken from a 1796 issue of *The Sussex Weekly Advertiser*, referred to the haunting of East Blatchington barracks at Seaford. Highlanders who were stationed there were spooked by the ghosts of another regiment of soldiers formerly stationed at East Blatchington. The phantom soldiers had belonged to the Oxfordshire Militia. The previous year, 1795,

the Oxfordshire Militia had mutinied, and for their crime they were executed. But they wouldn't go away and their ghostly presences continued to haunt the Highlanders who were still living in the barracks. So the Highlanders complained to their senior officers. Perhaps they hoped the army chaplain would conduct an exorcism.

The Tunnel Ghosts of Newhaven

Work was due to start the following year to open up catacombs of tunnels under Newhaven Fort said *The Argus* dated 16 December 1998. The tunnels were to become Newhaven's new tourist attraction, although the visitors would have to be prepared to encounter some spooky residents.

These were the labourers who built the fort during the 1960s. Apparently, staff had encountered the apparitions down below and were concerned that the work would disturb them. 'I just hope they can get along with us,' fretted the Fort's spokeswoman, Viv Samuels. She explained that she doubted the ghosts would like having to share their home. 'But they haven't got any choice really.' Viv added, 'Once, near the end of one tunnel, I was just stopped in my tracks. I couldn't breathe any more, and then it felt like somebody was pushing me and I was propelled out. It was as if somebody wanted me to leave.' The paper recorded that ghostbusters were invited to investigate the apparitions three years ago and they agreed that there were spooks in the tunnels. However, they were unable to evict the ghostly trespassers.

The Magical Manga Woman of Newhaven

Newhaven resident Debbie Wolf has been compared to the Manga comic book characters by their creators, the Japanese, who are impressed with her 'magical' powers. *The Argus* of 31 January 2008 tells how Debbie makes street lamps flicker, freezers defrost, televisions change channel and household appliances literally 'give up the ghost'. 'It happens if I'm stressed or if I'm chewing something over in my mind — but not if I'm annoyed,' she explained.

Once, when she was riding pillion on her boyfriend's motorbike the streetlights flickered on and off as they want past. On another occasion, when she saw someone she fancied in a bar, a blue jolt of electricity shot out from her foot to the young man's. Her mother said she couldn't take her into big electrical stores when she was a child and she also kept her distance whenever Debbie went to turn on a light. Repair men have often been observed working on the street lamp outside her house. She admits that 'The lights have always been faulty in all the homes I have lived in and I'm always draining the batteries in remote controls.' She also has to use a wind-up alarm clock because she 'scrambles' digital clocks.

Debbie Wolf has become famous, appearing on chat shows here and abroad. People who study the phenomenon called her a slider, short for Street Lamp Interference Data Exchange. There have been others who have also exhibited similar tendencies, although Debbie's experiences are more intense than those of most people.

SOUTHWICK MAN CLAIMS PROOF OF SURVIVAL AFTER DEATH

This story from the 1950s may be one of the most convincing accounts of contact with the 'other side' ever recorded. For a start, all those involved in the investigation were men of rank and integrity, most of who fought bravely in the Second World War; they certainly didn't need the publicity — and, in addition, all of their stories consistently support each other. It would have been even more extraordinary had this story been a fake.

The account appeared in *The Brighton and Hove Gazette* dated 4 February 1950 and was headed 'Southwick Airman and R101 Furore'. The previous week the Society for Psychical Research were occupied in an investigation into the destruction of an airship that had crashed in France in 1930. There followed almost a year of intense debate between rationalists and spiritualists due to the strange nature of the findings, which makes its possible authenticity even more impressive.

The Séance

A séance had been held two days after the 1930 crash, and as a result the dead pilot had connceted pyschically with a medium and given her the precise details of the incident. There was no doubt of the authenticity of the contact between pilot and medium, due to the technical knowledge and accuracy of the information given when later checked out with a government official. This astounding claim came to light when a Southwick man, 'tall, bearded, pipe-smoking' Flight Lieutenant William H. Wood of 104 Southwick Street wrote an article entitled 'Life After Death'. The article appeared in a rationalist publication called *The Freethinker*.

Mr Wood described to his readers how he had, twenty years previously, attended the séance that was held two days after the disaster. The séance had been arranged by the director of the Laboratory of Psychichal Research, the late Mr Harry Price, and the medium was Mrs Eileen Garrett, a woman with no knowledge of technical aviation terms. The purpose of the séance was actually quite different — the participants wanted to contact Sir Arthur Conan Doyle. But Conan Doyle, it seemed, was not available, and instead the R101 Captain, who was killed in the crash, came through — with incredible results.

His name was Flight Lieutenant Carmichael Irwin. Fortunately, a shorthand writer attended the séance and noted down everything that was said, and then passed on

the note to a Mr W. Charlton who was a government official. Mr Charlton knew all about the *R101*'s construction so he was able to assess the accuracy of the information imparted during the séance. All of his findings, which were entirely positive, were later verified at the official enquiry.

Mr Wood of Southwick

Mr Wood himself, the Southwick man, said that during the First World War he'd served as an airship pilot and had known Irwin very well. The paper added that Mr Wood was qualified to fly not only aeroplanes, but also airships, balloons and gliders — so clearly he knew exactly what he was talking about. His article, naturally, was sensational, especially as it appeared in a rationalist publication. His colleagues were upset and reacted furiously against him, and it is recorded that some of his detractors were actually abusive towards him. Eventually, the matter appeared in a column in the *Psychic News*, sparking off yet another debate.

The paper records: 'Meanwhile, Mr Wood sits in his cosy front room in his bungalow, vastly amused at all the fuss and bother.' After such a convincing experience, Mr Wood, the rationalist, now fully believed that spirit of the R101 Captain had continued in some form after death. 'You have only to prove a thing once for it to be true,' he declared.

The Conclusion According to Mr Wood

On the 18 February 1950, a letter from Mr Wood appeared in *The Brighton and Hove Gazette* regarding the evidence presented to the Society for Psychical Research in London on the 25 January. He said a paper he had written was read before the members. Mr W. Charlton explained to them the relevance of the technical information received from Flight Lieutenant Irwin, then deceased.

Air Chief Marshal Lord Dowding was completely satisfied that the case for survival after death was now proved after almost a year's intense controversy. Mr Wood added that the thing that convinced him first of all that he was dealing with a genuine communication with a dead man was that of Flight Lieutenant Irwin's speech. According to Sir Harry Price, the dead man's manner of speech was to use quick, short, sharp sentences. Also, the highly technical terms he used through the medium could not possibly be understood by anyone but an airship pilot. This meant that the usual objection put forward by sceptics — that the medium was able to read the subconscious minds of her sitters — could not be used. 'Not one of those present knew anything at all about airships,' said Mr Wood.

Mr Wood repeated that he was now *absolutely* convinced that there is life after death, even if other rationalists did not agree with him. 'They have been given every opportunity to supply an alternative explanation but they have failed to do so,' he declared.

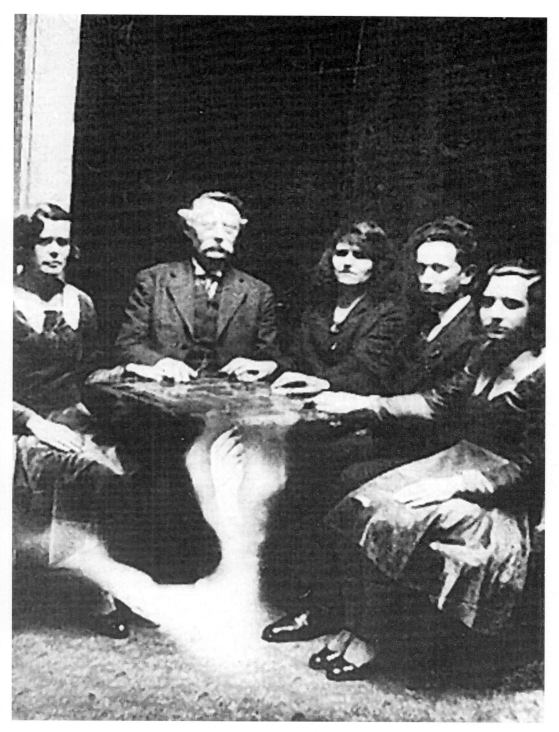

A séance *c.* 1920. Public domain.

THEATRE GHOSTS STILL SEEKING ATTENTION

When you've been watched, féted and flattered during your lifetime, asked for your autograph, received bagfuls of fan mail, and had your admirers swooning at your feet and sending you expensive bouquets and even diamonds and pearls — well, it could become addictive, even after death. It must be so disturbing to find yourself suddenly invisible. No compliments! No presents! Could that be why grand old theatres all over the country (and Brighton is no exception) seem to be haunted by the ghosts of those who once strutted, in full regalia, across their hallowed stages?

The Theatre Royal, Brighton

In a report in *The Argus* of Wednesday 11 April 2007, an electrician, Stephen Holroyd, tells of the time he was a trainee working at the Theatre Royal in the 1970s. He was only fifteen then, and he was amazed to discover that his fellow workers were petrified of a ghost called Myrtle of the Circle. Mr Holroyd explained how the crew often worked throughout the night at weekends to clear up the equipment from one play ready for setting up the next performance. These were mostly burly fishermen, who worked on their boats during the day.

Stephen would start work on the Saturday morning and continue until Monday night. The men and the theatre's nightwatchman would flee from the theatre just before midnight every Hallowe'en night. Stephen said he could hardly believe how superstitious these hardened fishermen could be, but by midnight they'd all be assembled safely outside the stage door.

Myrtle's ghost, apparently, walked around the Royal Circle, appearing and disappearing several times. It seems that the energy created by so much history and so many performances is the reason the theatre is so haunted. What with Myrtle, as well as the Grey Lady, it's all just too scary for words. The worst job for Stephen and his workmates was being responsible for putting out all the gaslights late at night.

Who is the Theatre Royal's Grey Lady?

The Theatre Royal has a very famous ghost although there is some debate about who she is. Some people believe the ghostly apparition is the French actress Sarah Bernhardt,

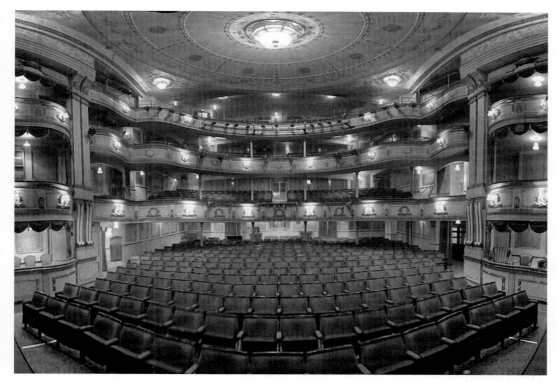

The Theatre Royal, Brighton, interior. Photo by Ian Muttoo (2007).

but others feel that's unlikely. Sarah Bernhardt performed at many different venues. She appeared at the Theatre Royal in the late 1800s, but since she worked in so many other theatres, why should she pick on one of Brighton's theatres for her haunting? It could be that an article in *The Argus* dated 7 February 2007 supplies the answer. Sarah Bernhart incurred an injury to her leg while she was appearing at the Theatre Royal. This injury later led to amputation, and it's been suggested that maybe this trauma has drawn her spirit back to the venue.

Some people believe it's more likely that the ghost is that of Mrs Elizabeth Nye Chart. Several members of staff have reported sightings. Mrs Chart was the first female theatre manager, taking over when her actor husband Henry died in 1876. Henry had bought the theatre ten years earlier. The theatre was famous for its pantomimes, and a free performance for the workhouse inmates was held each Christmas. In 1883, Mrs Chart lived at 9 New Road, and she died on 23 February 1892, by which time the theatre was well and truly established.

This elegant ghost, known as The Grey Lady, haunts the dressing rooms and has frequently been spotted in the theatre itself. One day, she gave one of the cleaners a shock by gliding past her and straight through a wall. Apparently, a doorway once existed at this point, which led to the upper stalls, but it had later been blocked off.

The Grey Lady's Identity — an Alternative Opinion

Not everyone believes the Grey Lady is Mrs Ellen Nye Chart. A report in *The Argus* dated 27 June, 2007 featured Brighton local historian Chris Horlock who told *The Argus* that he had seen one of the ghosts in a long corridor behind the back wall of the stage. In 1978, Mr Horlock was backstage during a performance of My Fair Lady. Just after the start of the second half, Mr Horlock said he was chatting in one of the corridor dressing rooms with two other people when a door burst open and twenty chorus members whizzed past them, having just finished one of their numbers. Everything went quiet, and then Mr Horlock heard the thud of a door. 'Someone's late,' he said. Then an amazing thing happened, a small, old lady silently passed the doorway.

'She was fierce looking and dressed completely in grey, period clothing,' said Mr Horlock. 'This was the Grey Lady, the Theatre Royal, Brighton's most famous spectre. She was more or less as others have described her and completely solid, with no see-through aspect at all.' Mr Horlock asked a companion who she was. Then he went into the corridor, but, of course, it was empty. The next room was also empty, but at the end of the passage, a door was suddenly flung open and more performers approached, pushing Mr Horlock back into the room.

'The ghost had gone.' But Mr Horlock was quite freaked out about the Grey Lady's timing. 'The Grey Lady had appeared when there was just a short lull in the show's comings and goings and the corridor was deserted for only a matter of seconds.' But Mr Horlock didn't think the ghost was Ellen Nye Chart, because she didn't resemble a photograph he'd seen of Mrs Chart. Nor was he scared and he said he would like to have another encounter with the fierce little old lady ghost.

Back-Up Evidence

According to *The Argus* report of 11 April 2007, stars claiming to have seen the Lady in Grey are Danny la Rue, Sylvia Randall and Michael Cashman. Another story concerns a manager who heard the thumping of a row of seats as he made his way late one night through the Royal Circle. Then the ghostly apparition of the Grey Lady appeared at the back of the auditorium, as though she was making sure everything was being done properly. According to *The Argus* dated 20 March 2008, a ghost, thought to be Mrs Nye, also haunts nearby bar The Colonnade, also known as the 'theatre bar'.

Similar stories have been reported by a doorman and a stage technician. The technical team is convinced the lady doesn't care for noisy performances and shows her disapproval by creating faults. When a boy went to the theatre for a performance of *The Twits*, by Roald Dahl, he saw a woman in a box dressed in costume from a previous century. However, when his dad checked out the story he found that no tickets had been sold for that box. On one occasion, a pianist engaged for a performance at the theatre went out onto his balcony and placed his hand on the metal railings. When he tried to take his hand away, he was unable to let go. He was stuck until, after several minutes, he managed to free himself.

The Theatre Royal, Brighton, opened in New Road on a site originally owned by George, the Prince of Wales, and the first showing was Shakespeare's *Hamlet* starring Charles Kemble.

The Grand

This old theatre is no longer standing, but its site is close to the Brighthelm burial ground. There have been three spooky stories reported. The first concerned a phantom in a bridal gown that appeared in one of the stalls one night. On another occasion, someone was heard singing the old First World War song 'Take me Back to Blighty'. This was thought to be the song of a soldier who had visited the theatre, and then, shortly after, gone away to battle and possibly been killed in action. His restless spirit continued to haunt the theatre. The last story concerned some cleaners who heard the sound of seats tipping up, one after the other, along the back row of the auditorium, exactly as though a line of people had just got up to leave at the end of a show. It must have frightened them half to death.

CHAPTER 12

PHANTOM SCREAMS OF TERROR FROM THE RAILWAY TUNNEL

Just five miles outside of Brighton, a terrible train crash occurred. The year was 1861 and the accident claimed twenty-three lives. One hundred and seventy-six other passengers sustained injuries.

Signalman Henry Killick was responsible for the signal, which he controlled with a wheel in his cabin. The signal had a default position of danger to which it returned automatically and remained until Henry Killick decided it was safe for a train to enter the tunnel. On 25 August 1861, three trains left their stations within minutes of each other at around 8.30 a.m. The first was from Portsmouth, the second and third were from Brighton. So there were actually three trains in the proximity at the time. This caused some confusion between two signalmen, Killick at the south end and Brown at the north end of the tunnel.

The first train passed in the normal way, but an alarm bell rang because the signal had not returned to its default position of 'danger'. Henry Killick sent a message to Brown at the north entrance to tell him there was another train in the tunnel. Unfortunately, the signal didn't return to 'danger' and the new train kept coming. Aware that the first train was in the tunnel, Henry Killick hurried from his cabin, wielding his red flag to stop the second train. He wasn't sure if the driver had seen him, so he telegraphed Brown to see if the tunnel was clear.

By now the first train had cleared the tunnel and Brown thought that was the train Killick meant, and so he signalled his colleague that the tunnel was clear. Killick thought Brown was referring to the train still in the tunnel, so he believed the train had emerged and the tunnel was safe to enter. Also, Henry Killick believed the driver hadn't seen his red flag. But the train driver *had* seen it and stopped in the tunnel. So Henry Killick allowed the last train to enter the south end of the tunnel.

Meantime, the train already in the tunnel began to reverse back out of the south end — and the speeding third train collided with it. It rode up over the roof of the carriage before coming to a stop, and this caused most of the deaths in the last carriage of the reversing train as the engine broke up.

Some of the bodies of the burned and scalded victims were taken to the cellar of the Hassocks Hotel. An inquest was held into the deaths and the jury criticised Charlie Legg, the assistant stationmaster of Brighton Station, for allowing three trains to leave their stations within such a short space of time. This was a practice forbidden by the railway company. Charlie Legg was tried for manslaughter but a verdict of 'not guilty' was returned. Both Killick and Brown were cleared of negligence.

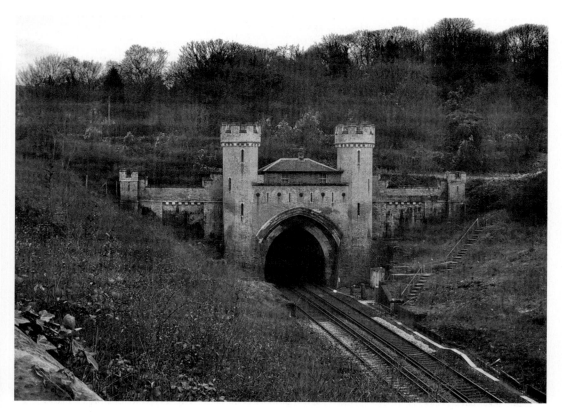

The railway tunnel entrance.

People have claimed to hear shrieks and screams from the tunnel, and the terrible crunching of trains colliding as metal scraped against metal. A nearby field where the bodies were laid is also reported to be haunted. This is a classic example of how a major tragedy can imprint its pain onto a place.

The Plot of Charles Dickens' Famous Story Based on the Clayton Tunnel Accident

The following is a summery of Charles Dickens' short story *The Signal-Man*, which was inspired by the Clayton Railway Tunnel Tragedy, as described on the Wikipedia online encyclopedia.

'The Signalman': The signalman is the narrator of the story. The ghost appears whenever a tragic railway accident is due to occur. Normally, when there's a threat of danger, the signalman is forewarned by telegraph or by an alarm. But when it's a 'phantom warning' only he, the narrator, can actually hear the bell. Each time this happens, a ghost appears just before there is an accident. The first phantom warning precedes a collision between two trains passing through the tunnel, the second the

death of a young woman, the third — that's what provides the twist. It's warning of the signalman's own imminent death.

An interesting codicil to the train crash phantoms is the story of the Clayton Tunnel Cottage, as reported in *The Argus* on Saturday 5 December 1998, when it had just gone up for rent. The cottage, dated from 1836, is located near the entrance to Clayton Tunnel. It was originally used as a wages office for construction workers and later, in 1841, it became a residence for railways employees. Muriel Attmere, who was a tenant of the cottage for forty years, died shortly after leaving her home in 1994. The cottage, it's claimed, is haunted by two ghosts, said to be victims of rail crashes (there was another crash in 1926). One of the ghosts is named Charlie and the other, the White Lady.

Phantom Soldiers

A few miles further down the line, sightings are reported of three First World War soldiers going into the Balcombe Railway tunnel. They were seen sometime during the Second World War when two living soldiers went to hide in the tunnel from a bombing raid — and saw, to their horror, the three ghost soldiers from the previous war. People claim the three phantom soldiers were mown down by the London to Brighton express train.

CHAPTER 13

BRIGHTON'S MOST HAUNTED HOUSE — PRESTON MANOR

On 9 February 2005, a story appeared in *The Argus* concerning a six-year-old tabby cat called Kitty. Animal Welfare Officers, who said she wasn't being properly cared for, removed Kitty from Preston Manor. Staff and members of the public felt this was rather heavy-handed. Kitty had been quite comfortable sleeping in the toolshed and spent a lot of her time happily curled up in the gardener's wheelbarrow. Cats' Protection insisted she was technically a stray, but their switchboard was jammed with calls for her return to Preston Manor. The caretaker Hannah Schaefer offered to care for Kitty at her cottage. 'The ghosts are not happy that Kitty has gone missing,' she said.

Considering the catalogue of supernatural occurrences below, that's far too many ghosts to ignore.

A Magnet for Paranormal Activity

Dating from the 1600s, Preston Manor is, allegedly, a magnet for ghostly happenings. According to reports corroborated by ghost tour operators, paranormal investigations and the sightings of those who work at the manor it is one of the most haunted buildings in Brighton. The word 'Preston' means 'priest's holding' and it is believed the site was a monastery in the Middle Ages, which might account for some of the more bizarre paranormal activity. Some guests have reported experiencing very negative vibrations, especially in certain rooms where someone has died.

A Summary of Regular Paranormal Activity at Preston Manor

These are some of the other supernatural events that have been recorded:

* People have found themselves locked inside rooms when no one else is present.
* A Grey Lady slowly descends the grand staircase. She first appeared to firewatchers during the Second World War.
* In the 1950s, the caretaker's children reported ghostly sightings.
* In the 1960s, someone saw a ghost playing with a child's toy tractor.

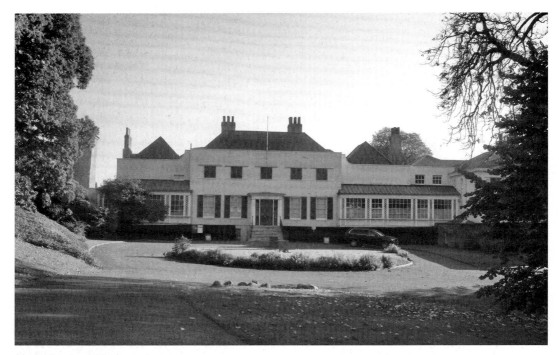

Preston Manor, front elevation. © Janet Cameron.

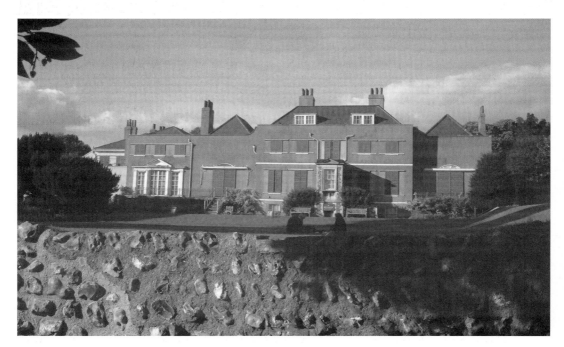

Preston Manor, rear elevation. ©Janet Cameron.

Sign outside Preston Manor to publicise its ghost tours. © Janet Cameron.

* One of the ghosts is reported to be that of a medieval nun, Sister Agnes, who helped travellers to find their way.
* Doors slam shut and lights turn off without any apparent explanation.
* In the most haunted room, the north-west bedroom, guests have reported witnessing a disembodied hand that floats around a four-poster bed.
* A disembodied hand turns a doorknob (it's not clear whether this is a different hand from the above or the same hand).
* Voices have been reported shouting at people. Often, no one else can hear them, only the person being shouted at.
* Inexplicable lights and auras appear, claimed to represent the dead. There's moaning and groaning, icy blasts and peculiar smells.
* A child's voice is heard in the nursery, imploring for attention, and on 17 October 2004, a small child was reported laughing in the attic.
* Ghostly apparitions appear at windows.
* Mediums have reported seeing dead people standing amongst the visitors.
* There have also been claims of sightings of ghosts in the Preston Manor's churchyard.
* This is a strange one — a wardrobe in the manor causes clothes to develop a cut-in diamond pattern.

* Ghosts have been found to appear in photographs, although they were not visible at the time the pictures were taken.
* Voices, in particular those of children, have been heard on audiotape, although they were not heard at the time of the actual recording.

The Old Preston Church (dedicated to St Peter) on London Road

This church was once owned by Preston Manor and is next-door to it. An account in *The Brighton and Hove Gazette* dated 30 September 1966 tells us more about some of the hauntings that took place in and around the building, which dates from about 1250.

The White Lady is Buried in Consecrated Ground (but does she know it?)

The most fascinating story is that of the White Lady. It's said a lady in white once haunted the Stanford family, who were private owners of Preston Manor for four generations, from 1794 to 1932. The Stanford family were so frightened by the level of paranormal activity that, in the late nineteenth century, they asked a medium to intervene for them.

The Argus, dated 18 October 2004, reported that a séance was held in 1896, and it was discovered that the White Lady was the ghost of a nun excommunicated for her misdemeanours and murdered. Then, the so-called 'Mad Jack', the son of the last owner, Ellen Stanford, claimed he discovered a nun's skeleton buried in the garden and arranged for it to be buried in consecrated ground.

Geraldine Curran explains how the family had problems with the drains, so they dug up some pipes and nearby lay a female skeleton, believed to be that of a nun. They informed the vicar of St Peter's at Preston who refused to bury her in a Church of England burial ground because she was a papist. So the skeleton was buried at night in consecrated ground, without the consent of the vicar.

Despite the séance and the burial in consecrated ground, Preston Manor's White Lady is said to continue to drift around the manor and the old church. *The Brighton Gazette* report of 1966 takes up the story, with small variations. People had become accustomed to the hauntings in the area and took little notice of them. Then, one day, to his great astonishment, an army officer saw the ghost. He was quick-witted enough to ask it (or her) what she wanted. The White Lady said, 'I was a Religious'. A 'Religious' was a nun of a pre-reformation religious community and this dated the White Lady's death at about 350 years before the sighting. Then the ghost continued by telling the army officer that she was wrongly excommunicated.

'My body was not allowed to be buried in consecrated ground. I should like to have Masses said for my soul and to have my body interred in sacred soil.' The army man said he was able to help. He spoke to a priest about the White Lady's request and Masses were offered for her soul. Didn't she realise her body had been exhumed and reburied in consecrated ground? For surely that must have cancelled out her excommunication.

The Gazette confirmed that, indeed, in 1897 a female skeleton was found beneath the floor in the south-east corner of the manor. It was claimed to be around 400 years

old, so the remains, assumed to be those of the White Lady, were buried in the sacred ground of the churchyard. This seems to tie up with the kind act attributed to 'Mad Jack' Stanford. After that, says *The Gazette* report, she was never seen again. Except, of course, that's not what they say today at the Manor! Because, although the paranormal appearances stopped for a while, according to modern reports she is back again and up to her old tricks, scaring the daylights out of visitors and staff.

It's also just possible she might have appeared again, later, during the Second World War.

Face in a Mist — The White Lady Walks Again?

A relative by marriage of Geraldine Curran's, Mick, said that his father was a nightwatchman during the war. He had to go into the manor in the early hours of the morning. In one of the rooms on the ground floor, he suddenly felt a cold chill and turned to see the ghost of a woman's face staring at him. The face seemed to be floating in a misty body. He ran out, petrified.

Finally, when the last of the family died, the house was gifted to the Corporation of Brighton and is now a museum. It's also suggested that 'Mad Jack', an irrepressible and wayward family member, is responsible for pinching ladies' bottoms, a trick no doubt helped by the extra paranormal energy he gains by draining the batteries of the visitors' cameras. (Some humans can do this too — see 'The Magical Manga Woman of Newhaven' at the end of Chapter 8.)

Not Irrefutable Proof, but…

A report by Rachel Pegg for *The Latest* (www.thelatest.co.uk/7) dated 26 March 2008 says, 'We are taught that, while on investigations, it is common to be unable to hear or see ghosts at the time, but to find evidence of them later, on photographs and voice recordings — no Photoshop allowed.' Rachel Pegg had been on a ghost tour at Preston Manor and saw some of The Spirit Parlour's unexplained light effects and auras. (The Spirit Parlour was the organiser of this event.) These effects and auras, they claim, are the souls of the departed. Ms Pegg also documents hearing a recording of a child's voice whispering in the nursery. The voices of the investigators were heard at the scene of the investigation, but not the child's voice — that is, not until the tape was played back later. In response to her visit to Brighton's most haunted house, Rachel Pegg says, 'I'm not saying that's irrefutable proof of an afterlife, but it certainly did make me think.'

If you want to experience the eerie atmosphere of this haunted manor, special ghost tours are a regular attraction. Some of these allow visitors to use special equipment to aid the investigations. Reassuringly, it's reported by guides that none of the ghosts ever do any harm to visitors.

HAUNTINGS AROUND CHURCHYARDS, OLD BURIAL GROUNDS AND CEMETERIES

Modern cemeteries came into being in the late eighteenth and nineteenth centuries, when a burgeoning population meant space in church graveyards and special burial grounds was beginning to run out. Sometimes churches sold off their land, and the bodies had to be exhumed and re-interred in cemeteries. In earlier times, roads from distant locations to the site of the parish church were always dead straight, like ley lines, so that coffins could be more easily conveyed — or even carried in the case of poorer people — to their resting place.

The Skeleton Horse of St Nicholas' Church

Thought to be one of the oldest buildings in Brighton, dating from the fourteenth century, St Nicholas' church is haunted by the spectre of a white horse, sometimes reported to gallop around the church and sometimes galloping for its life away from the church. Builders laying cables discovered the skeleton of a large horse buried in the churchyard and the evidence seems to point towards a religious sacrifice in much earlier times, when such rituals were common practice. Yet other accounts report the horse carries a phantom rider.

The Devil Gets in on the Act

There's an old legend that the devil, given his hatred for churches, disguised himself as a woman who offered a vase of oil to some pilgrims, with which to anoint the church. What they didn't know was that the vase contained a stone-burning liquid. Clearly, it didn't work!

The Ghost Ship

Also, there are several variations on a legend about a sighting from the church of a ghost ship at sea, which can be viewed either from the high ground or from the church spire. In one story, a love-struck young girl shinned up the spire to see if she could see her lover's

St Nicholas' parish church, Brighton. © Gareth Cameron.

ship out at sea. When she spotted it, she could see it was on fire in Shoreham Harbour. The poor young girl fainted, fell to the ground and died. The date was 7 May and every year, on that date, it's claimed her ghost hovers around the church and graveyard.

St Nicholas's Spook Nun Invades the Sergeant's Mess

A story in the *Brighton and Hove Gazette* dated 21 May 1949 tells of yet another strange paranormal experience emanating from St Nicholas' churchyard. The writer's name did not appear on the article; possibly they preferred to remain anonymous. The incident happened in the Sergeants' Mess at Queen's Hall Square, at the Drill Hall, Brighton, and the article was entitled — appropriately — 'Ghosts in a Mess'.

While in the mess, the writer heard someone chanting, 'Don't hang about or the old grey nun will get you'. He asked the RSM who the old grey nun was, and his colleague took him to talk to sixty-three-year-old Sergeant Welfare in the billiards room. Welfare threw open the window, revealing below the graveyard of St Nicholas' church next door. This place of burial dated from Saxon times, and all the gravestones, where monks and nuns had been buried centuries before, looked really eerie in the moonlight.

'There was a saying in the mess, before my time, about the old grey nun,' Welfare said. 'There have been stories. One night I was working too late to go home, so I slept in the billiards room. Something woke me up in a fright. It felt like a cold, clammy hand touching my face. There was something uncanny.'

After this spooky incident, the sergeant continued with his story, explaining how, about two years ago, he was back from Germany having spent a month in hospital, recovering from his wounds. While in the Drill Hall workshop, late at night, he had a sudden peculiar feeling. (The Drill Hall was claimed to be *underneath* the cemetery.) The atmosphere had become cold and clammy and something — he wasn't sure what — made him feel very uneasy. Then every door in the long passageway opened and closed as though some strange presence was passing through. But there was no other human being present.

Sergeant Welfare decided to get out of the building immediately. But this was not the end of his ordeal, because in the passageway he fell over a life and force pump. This had clearly been moved by some unforeseen force, as he remembered it being stacked close to the wall when he'd walked down the passage to the workshop. No human agency had moved it — so what had? Sergeant Welfare was confused and scared.

'I am not superstitious,' he said, 'but I have not worked in that place since.'

All Saints' Church, Patcham — a Surprise Visit

When the congregation gathered for the Christmas Evening service, people were surprised to see a strange, sick-looking woman sitting in a pew. She looked so white and cold that someone tried to put a coat around her — but she simply vanished.

Patcham's Grey Lady and the Gentleman's Coat

A strange encounter occurred outside a church in Patcham in 1879, although this time the name of the church wasn't recorded. The story has similarities to the one above and is told in a nostalgia feature by Barbara Bailey in *The Brighton and Hove Gazette* dated 28 December 1979.

A 'very gallant' young man was confronted by the grey lady, 'shivering as always'. The young man didn't realise this was a ghost and, feeling sorry for her for being so terribly cold, he handed her his coat. The lady swept away with the coat, and then the shocked young man realised that she was actually a ghost. Fortunately, the next day he found his coat where she had later dropped it.

In his old age, the man told the story to his daughter, adding that the coat had remained *brand new* for seventy years.

Revelations at a Séance

Other nuns are claimed to have been seen in the churchyard, and there are records going back to 1535, says *The Brighton Gazette*. During a séance, it's said, two nuns communicated from the dead, naming themselves Agnes and Caroline. Today, some people describe the undertaking of a séance, or communicating with the spirit world via a medium, as 'channelling'.

Other Sightings

Members of the church choir claimed they had seen a ghostly figure emerge from the south side of the church and disappear into the churchyard. In another instance, on a sunny morning, two people passed the church, only to meet two women dressed in medieval clothes. What is really spooky is that the two ghostly figures walked with them for a while but then passed through some terracotta tombs on the west side of the churchyard.

On another occasion, in the '70s, there was another similar sighting. The ghost of a woman appeared, and it looked so real that two people walking past tried to speak to her. To their amazement, she slowly faded and disappeared.

Around 1956, two boys were having some fun conducting their own ghost hunt among the gravestones at the old church. But as they played among the graves, a figure in a black hood appeared and terrified them half to death. Transfixed, they watched the spectre, which walked across the churchyard, vanishing as suddenly as it had appeared.

The most recent ghost (at the time of writing, in 1966) was claimed to be that of Sir Charles Thomas Stanford. He had died early in the twentieth century and his ashes had been interrred in the south corner of the churchyard. It was also claimed that Lady Ellen Stanford's ghost had floated by and disappeared straight through a wall just outside the building.

The old Brighthelm burial ground that frightened the children. © Gareth Cameron.

A Nasty Shock for the Kids at the Old Burial Ground at Brighthelm Church

A similar incident to the one above involving the two boys at the Preston Manor burial ground in 1956 also happened at the Brighthelm burial ground. Today, the old burial ground owned by Brighthelm church has been re-arranged; all the ancient tombstones have been lined up side-by-side around the perimeter of the area. But in the 1960s, around dusk, a group of children went to the churchyard to play and — to their horror — a dark hooded figure appeared and glided across the grass, finally disappearing through a tombstone.

A Monumental Mistake!

This ghost story was told in a letter to *The Brighton and Hove Herald* dated 27 October 1928. The writer of the story discovered it in the Brighton Reference Library in the October issue of the *Journal of Psychical Research*.

Fifteen years previously, which would be around 1913, Herbert Jones, the Bishop of Lewes and Archdeacon of Chichester, had been touring the county. He stayed with a rector who recounted how an elderly gentleman had made his fortune in the East, and returned to live in the parish. Sadly, shortly after his arrival, he died.

A fine tombstone was erected over the gentleman's grave, and then his family moved some distance away. One day, the son-in-law of the deceased gentleman called on the rector, saying that his wife was suffering from a recurring dream. In the dream, her father appeared to her, distressed that his tombstone had been erected over the wrong grave. The rector appealed to the sexton, asking if it was possible.

'Quite impossible,' said the sexton. 'My brother died just after Mr X, and he was buried in the next grave, and I could not have made any mistake when the tombstone was put up.' The son-in-law departed, satisfied with the sexton's response. However, he returned after a few weeks. His wife's dreams were worse than ever and he feared for her sanity.

A Home Office permit to exhume was granted, and when they opened the grave, they found the monument had been erected over the coffin of the sexton's brother. As soon as the mistake was rectified, it was clear the wife's dream was in fact a genuine haunting, because from that moment, the dream, which was really more of a nightmare, stopped.

St Helen's Church, Hangleton

In the 1950s, some children believed if you poured water on a grave then a ghost would appear. So they experimented with a small jug of water in the old churchyard, throwing it onto one of the larger graves — and sure enough, there was a sudden, panic-stricken cry. A white spectral figure had risen from the old tomb — and the terrified children took to their heels.

The Problem of the New Graveyard

In olden times, there was a dilemma when a new graveyard was first opened. No family wanted to the first to bury their relatives there, because of a strange belief. This was that the very first corpse interred in a newly-opened burial ground became the property of the Devil. Sometimes they got around this by burying the body of a tramp, or maybe a servant would do, especially if their work wasn't satisfactory!

GHOSTBUSTERS INVESTIGATE A HAUNTED HOUSE IN HOVE

A report dated 7 October 1953 appeared in *The Argus* headed 'Sussex Ghost Men Go A' Hunting Again'. The following Saturday, the Sussex Ghost Hunters were planning a vigil using state-of-the-art equipment of the time, by tracking ghosts with radar and tape recorders. The venue: a 200-year-old house in Hove; the target: two ghosts and a poltergeist. The name of the person living in a house was not revealed, probably to avoid being descended upon by crowds of curious locals.

The house was claimed to be near Old Manor House on the Wick Estate. Mr Ted Henty, the leader of the ghost hunters, explained how one of the ghosts had been 'giving a lot of trouble', scaring off caretakers and also some soldiers who lived in the house during the war. The house had now been empty for twenty years — no one was brave enough to live there before.

Details of the haunting included paint bottles being moved out of locked rooms and left in the hallway, heavy corks being taken from acid containers and locked doors being found open. A caretaker witnessed a male apparition on the ground floor, and outside, in the grounds, he saw the ghost of an Indian woman.

The ghost hunters expected to spend all of the previous afternoon and part of the night sealing the rooms and checking out their equipment. They were also to be filmed by Associated British Pathe and the film was to be shown in all the country's cinemas. A summary of the vigil, which was carried out on Saturday 10 October, was published on the 12 October 1953. Although the cameramen did his best, he didn't manage to capture any image of ghostly phenomena, and he returned to London.

Owner Insists it's a Genuine Haunting

The resident's name was now revealed as Mr Dudley Gamble-Jones, who insisted the house was haunted in spite of the disappointing outcome of the ghost hunt. He said he'd leased the house in the first place because it was reputed to be haunted — and he'd always wanted to live in a haunted house. He was convinced the poltergeist was entirely genuine, because of the locked doors that suddenly became unlocked as well as the ornaments that changed position in the rooms. Most of the paranormal activity occurred across the passageway.

This was the fourth time a ghost hunt had been arranged at the house. Mr Henty said, 'Perhaps it is a friendly ghost that is shy of strangers.'

The next day *The Argus* published a letter from the branch secretary of Phantoms Union, Hove Branch. 'So the ghost would not walk for the newsreel man?' began the letter rather cryptically. 'How long is it going to be before the pseudo scientific psychic researchers realise that no self-respecting ghost puts in an appearance before arc lights, radar screens and electric eyes?' Furthermore, the Phantoms' Union had laid down rules. 'Ghosts shall only walk for the purpose of scaring humans, not to entertain or amuse them.'

You have been warned! (Although I wonder whether the ghosts know about the Phantoms' Union's rule!)

CHAPTER 16

A SERIAL ADULTERESS HAUNTS THE BLUE GARDENIA NIGHTCLUB

They were found in bed together, sitting side-by-side, his arm around her shoulders, and they appeared to be peacefully sleeping. You'd never guess, at a first glance, that there was anything amiss. Except, as Detective Constable Terry Sullivan and two fellow officers looked closer they could see that Christine Holford's face was covered in blood and her right eye was open, staring fixedly at the ceiling.

The husband beside her, wearing a white singlet, was Harvey Leo Holford, aged thirty-four, the owner of the Blue Gardenia Club at 4 Queen Square, Brighton. The twenty-one-year-old wife Harvey Holford had just murdered was still wearing her white pullover over a green blouse and black matador tights. The murder of Christine Holford took place on 15 September 1962. (Her story was retold in detail by Michael Thornton on *The Mail Online*, 7 July 2006, which was the day after Holford's funeral, following his being diagnosed with leukaemia.)

The *MailOnline* account tells how after the murder, back in 1962, Harvey was unconscious from a barbiturate overdose. When the officers looked under the bed, they found the revolver used to shoot Christine. She had been shot three times in the head, once through the front lower jaw, again through the right temple and also through the left ear. There were a further three gunshot wounds to her body.

When Harvey and Christine were married, she'd quickly became bored with her husband, and when he financed a holiday to France for her, accompanied by her friend Valerie, Christine took off her wedding ring and found herself another man, a Swiss student called Vilasar Cresteef. Then the girls went to San Remo, where Christine slept with a German drummer and an Italian restauranteur. After that, there were two more Germans. When Holford finally went to the continent to fetch her home, she told him she'd found someone else, a Jewish man called Bloom. After some argument, Christine eventually agreed to return to Brighton with Holford on 11 August 1962. But the couple continued quarrelling, and eventually Holford lost his temper and murdered her. He escaped a charge of murder due to his wife's provocation and received instead a reduced conviction of manslaughter. He went to prison for three years.

Poltergeists are commonly believed to appear when something extremely bad has happened, for example a brutal murder, so it's not surprising to learn that it wasn't long after Harvey Holford's conviction that lights in the building kept turning themselves on and off. Articles, for example kitchen utensils, began to move around the place of their own volition. It seemed that this must be the disturbed spirit of the murdered woman

creating havoc in the nightclub. One man reported that there was also some poltergeist activity in the Whiskey-A-Go-Go, a café beneath the Blue Gardenia. Eventually, it's claimed, a medium was called in to lay her spirit to rest and so the poltergeist disturbances faded away.

The Whiskey-A-Go-Go

Between 1976 and 1979, Geraldine Curren used to visit some friends who ran a UFO Research Group at their flat at No. 4 Queen Square, the location of the former Whiskey-A-Go-Go. Although she didn't participate in their sessions with the ouija board, she was told the couple had called up some 'very bad spirits' in the flat.

The 4 Queen Square address now belongs to a solicitors' practice.

CHAPTER 17

HAUNTED HOVE, PARANORMAL PORTSLADE AND SUPERNATURAL SOUTHWICK

Portslade and Southwick lie to the east of Hove, between Hove and Shoreham. The first account of ghosts that haunt the beaches and the squares of Hove are now part of its legend and folklore.

The ghost of a white dog almost as big as a horse is said to roam around beaches in the Brighton and Hove area. It follows walkers and then vanishes. (Ghostly black dogs are claimed to be the Devil in disguise, but fortunately all accounts report that Brighton's ghost dog is white.)

Long ago, a ghost known the Wick Woman (or Wick 'oman, as she's labelled in old books) is claimed to have terrorised little boys venturing down to the beach at night. She haunted the gap, a simple country track that once ran down to the beach from what is now Lansdowne Place. Little boys who crossed the fields before coming to the Lower Wick Pond (formerly in Western Road to the north-east of Landsdown Place) on their way to 'The Post' to bathe, were disturbed by her 'echo', which lingered in their memories.

There are several definitions of the word 'wick' but in this case it's probably used to describe a bundle or loose twist of soft threads, or a woven strip of cotton used in a candle or lamp to draw up the melted tallow or wax to be burned. Perhaps the woman behind the ghost was a seller of such items, or used a candle or lamp to skulk around near the beach, scaring the boys when she was still alive. She must have a very serious grudge against little boys to continue the practice after death.

If the old Wick Woman wasn't enough, there was another terrifying old woman called Betsy Bedlam, who also terrorised children around Belle Vue Fields, where there was a capstan and an archway. The area is now Regency Square.

A more recent sighting happened in 1977 when a man in period clothing and a tall hat took a ghostly promenade and then disappeared.

Phantom Footsteps

The Hove Museum and Art Gallery was once called Brooker Hall and was built in the Italian style of Queen Victoria's Osborne House on the Isle of Wight. During the First World War, German prisoners of war were housed in the building. Could it be their phantom footsteps heard traipsing around the outside of the building? No one knows for sure.

A Gravestone from afar in Portslade

Portslade is an area of Hove lying to the west. There are two distinct parts to Portslade: the original sixteenth century village, which lies a mile inland to the north, and the more modern area near the coast, which was developed after the railways were up and running in the 1840s. The coastal area is now named Portslade-by-Sea.

A weird incident occurred here in the '80s on the fringes of the old village. It's not possible to say for certain whether or not this was of a paranormal origin, but it's hard to find any other explanation. An article entitled 'Mystery of a Soldier's Gravestone' appeared in *The Argus* dated 3 July 1986. A Second World War soldier's memorial headstone turned up on a Portslade footpath — on the day of the Somme anniversary. Mr Rodney Patterson, who lived at Drove Crescent, was walking along the footpath when he made an extraordinary find.

'It just suddenly appeared out of nowhere, and parts of it were missing. It's very mysterious. There is no cemetery for a couple of miles around here and I use the footpath regularly,' said Mr Patterson.

The broken headstone part carried the crest of the Essex Regiment, the rank of the dead soldier, his initials, A. J. W., and the first three letters of his surname, 'BRY' (for Brydon). He died on 3 April, but the year was missing. Mr Patterson checked with the Imperial War Museum, the Essex Regiment Museum in Chelmsford and the Commonwealth War Graves Commission. After talking to these institutions, he was convinced the headstone was genuine and discovered something about how Private Alfred John Brydon, aged nineteen, had met his death.

Alfred Brydon served with the 10th Battalion of the Regiment and died 3 April 1918. He was laid to rest in the Nampsau-Val cemetery in France. On that date, his regiment was serving on the Western Front, east of Amiens. The soldiers received instructions to hold ground against the strong onslaught of the German army. When a German bombardment smashed into them, the men suffered heavy casualties.

The conclusion was that Alfred Brydon had probably died in action, although it was not possible to be one hundred per cent sure.

Poppy

A Hove woman was talking on the phone to a friend, who was reminiscing about his wife, who'd died thirty years' previously. He'd decided to revisit where he had lived with his wife and went to the station to buy a ticket.

'I seemed to be having a vision of his movements as if I was watching him from above. At the same time I felt some sort of presence in the room. It was not at all scary,' she says. 'It was as though I was seeing what was happening through someone else's eyes.

While she was in a state of clairvoyance, a voice murmured the word 'Poppy'. As her friend continued with his story, the word was repeated. Finally, he changed the subject and her vision faded. 'I've got to tell you what just happened,' she said and explained her strange experience.

There was a long silence, and then the man told his friend that in happier times they'd agreed on a 'code word', a sort of psychic signal between this and the 'other side', for when one of them died.

'Poppy' was that code word.

Portslade's Haunted Tower

Foredown Tower was once a water tower, built in 1909 and subsequently converted. It's now a viewpoint, offering panoramic vistas across the surrounding countryside. It contains a camera obscura (*obscura* is Latin for 'dark room'), a device that projects an image of the surrounding scenery onto a screen and is a precursor to photography. Like Brooker Hall in Hove, there are phantom footsteps in the tower as well as other paranormal noises and a sighting was reported in the nineties of a ghostly figure swirling in mist — although, strangely, there was a glimpse of tweed material below the mist.

Where are Mulder and Scully?

Not everybody realises that poltergeists can even cause fires. But this is what happened to a Southwick couple. Southwick is actually in the Adur district of West Sussex, although it's rated as a resort of Brighton and Hove. It also has a strong Roman history and its Methodist church is built on the site of a Roman villa.

Mr Mower, who experienced the fire-related poltergeist phenomenon, said, 'It's absolutely bizarre. We just can't believe it.' The report of the fire appeared in *The Argus* dated 23 February 2006, and it happened in the living room of a Southwick couple, George and Eileen Mower. George and Eileen, who lived at The Crescent, were decorating their house and they'd spread a white dustsheet on the floor before stripping off the old wallpaper and scrubbing down the paintwork. Overnight, the white dustsheet turned into black ash although there were no chemicals around. As Mr Mower explained, 'The fire actually burnt round a plastic bag full of wallpaper that was on top of the sheet. It's like something from the X-Files. I'm thinking of calling Mulder and Scully.'

There wasn't any major damage, although the carpet was singed. Understandably, George Mower said he was feeling 'a bit spooked'. Especially since he'd got up to let the dogs out several times in the night and had walked right past the door to the room being decorated. Neither he nor the dogs had smelled or suspected anything and the blaze didn't even set off the fire alarm.

The fire investigation officer couldn't understand it either, as there was no obvious ignition source. Cautiously, he said, 'I've been doing this job for fifteen years and I've never seen anything like it.' Later he added hopefully, maybe *too* hopefully: 'There's definitely a scientific explanation.'

CHAPTER 18

SPOOKY SHOREHAM—BY—SEA AND STEYNING

The small town of Shoreham-by-Sea, established by Norman conquerors in the late eleventh century, is situated between Hove and Worthing. It became a seaport, complete with busy shipyards, in Victorian times. The town is now described by ghost-tour operators as 'Spooky Shoreham'.

A Strange Wailing near the Cemetery

Older people in Shoreham can remember way back to the 1940s, and for some years after that, when a terrible wailing was heard from Mill Lane Cemetery. When they heard this awful noise they ran like mad to get away from the darkness to the bright lights and safety of the main road. Some people thought these piercing noises were the cries of the dead people buried in the graves, but others insisted they were the spirits of mariners lost at sea, who wanted to be laid to rest in their own special place in the graveyard of their hometown.

The Paranormal Flipside of Adur Civic Centre

The Civic Centre at Shoreham seems to have been a hive of ghostly activity; sightings have occurred since the 1980s. The building was once the Coliseum cinema and was also used as a place to meet by soldiers during the First World War.

A member of staff working late heard the sound of the large front doors opening and closing. He rushed to see what it was, as no one should be in the building at that time. He saw the back of the ghost of a young woman. It's impossible to explain why the ghost needed to open the doors instead of just floating through them and it is possible the man might be mistaken.

On the upper floor of the building a pair of disembodied ankles and feet appeared in front of a horrified cleaner, while someone else saw a ghostly figure in a green haze close to the vending machine. It's claimed the ghost of the former caretaker, who was electrocuted on the site, haunts the upper floor of the building and is responsible for the unexplained pealing of a bell.

Left: The Mill Lane cemetery at Shoreham. © Janet Cameron.

Below: Shoreham's Civic Centre. © Janet Cameron.

Southlands Hospital Freaks Out Medical Staff

The medical records section of Southlands Hospital dates from the '70s, and during the 1980s it was claimed to be haunted by a grey lady. The medical section was in the basement directly beneath the out patients department and adjacent to Hammy Lane. Staff and porters were freaked out by the ghost and hated going to the medical section outside of hours.

There was once a house on the site, and as ghosts tend to haunt sites and don't just disappear because a new building has been erected, the haunting may date from that time.

Ghosts of the Workhouse

The site of Somerfields in Shoreham was occupied by a hospice, a school and a workhouse before the building was demolished in 1970 for the erection of the supermarket. Apparitions of young girls in grey dresses and white pinafores have been seen, together with a phantom man in black with a top hat. It's thought these were the former occupants of the workhouse, the man in black being in charge of the operations. Another possibility could be that these are pupils from the time the school stood on the site, and that the young girls were pupils and the man their headmaster.

Screaming Maude

The cries and screams of Maude of Ditchling are heard from the ruins of Bramber Castle in Steyning. The story goes that her lover, Sir William De Lindfield, was bricked up in a dungeon in the 1400s. Her husband had discovered her infidelity and wreaked a terrible revenge on his rival. Maude lost her life the next day, presumably at her husband's hands. Her ghost continues to lament the fate of her tragic sweetheart by wandering among the ruins, crying and screaming. Bramber Castle is a stone motte and bailey castle dating from around 1070.

Church of St Andrews and the Miracles of St Cuthman and Moaning Milian

St Cuthman is said to have founded the wooden building that once was the Church of St Andrew in Steyning. St Cuthman was born in 681, probably in Devon or Cornwall. He was a shepherd whose widowed mother was paralysed, so while he travelled he pushed the old lady in a wheelbarrow, with a rope placed around his shoulders to help support the weight. When the rope finally broke, he decided that was a sign from God and so he stayed in Steyning and began to build a church. (The church now on the site is called St Andrew's.) The legend says that St Cuthman had difficulty with a roof beam and a stranger helped him. When he asked the stranger his name, the stranger replied, 'I am he in whose name you are building this Church.' (Wikipedia, reference *Acta Sanctorum, Vol 11*, pages 197-199.) After this St Cuthman went on to perform a number of spectacular

Tombstones in the graveyard of the Church of St Andrew. © Janet Cameron.

miracles and caused anyone who thwarted him to receive severe divine punishment. By all accounts, he was a rather bloodthirsty and unforgiving saint.

An occultist called Rupert Matthews claimed, in an article in *The Argus* on 13 February 2007, that the present fine church is now haunted by Milian, a holy woman. Or maybe 'holy terror' would be a more appropriate description.

Milian, said Mr Matthews, arrived in the thirteenth century for sanctity at the church, seeking enlightenment. Local people were kind and welcoming, but the holy woman was argumentative and, unfortunately, also into heavily into litigation — she started lawsuits against the local vicars and made herself most unpopular. After her death, her ghost continued to appear, as if to show everyone how much she disapproved of the current priest.

However, Moaning Milian's presence eventually began to fade and soon she was merely flitting around the churchyard.

A CLAIRVOYANT HOLDS A SÉANCE AT THE ROYAL PAVILION

'I hear voices... I am clairvoyant... I come into contact with those who have passed into the other life...' So reiterated a renowned clairvoyant in the summer of 1933 at a special talk and séance at the Royal Pavilion. A report of the event appeared in the *Brighton and Hove Herald* dated 26 August 1933.

The Revd Will Erwood spoke to a rapt audience — mostly women — on the previous Wednesday 22 August. The paper recorded that he was an ordinary, middle-aged, grey-haired man but smartly done up in evening dress. He had come from the United States especially to entertain them with his paranormal skills and convince them of his belief in spiritualism. He was closely connected with the Brighton National Spiritualist church in Mighell Street, which had recently opened a Sussex Psychic Research Bureau to help would-be investigators.

The Demonstration

A steward arrived and handed Mr Erwood a tray on which lay a large number of buff-coloured envelopes containing questions from the audience. Mr Erwood's role was to sense the questions in the sealed envelopes and to reply to them. This he did — and more! In some instances, he described the person who had passed on, including the tiniest details, for example he divined that one had a smallpox mark on the nose. He told one member of the audience — correctly — that her loved one had died as the result of a stroke. Then, to a lady in a white hat, he claimed he saw beside her a young girl, 'like a lily' and 'with hair like burnished gold'. The beautiful young girl put her arms around the woman's neck. She had, said Mr Erwood, passed on after receiving an injection from a doctor.

The woman nodded. 'My niece...' she murmured.

A Plea for Religious Tolerance

Mr Erwood made a plea for tolerance, not only for spiritualism but also from spiritualists towards those of other denominations. He wanted to show that spiritualism is part of religion and is not out to destroy other faiths. Central to his beliefs was the fact that man lives after the death of his body as a conscious being.

CHAPTER 20

INTOLERANCE TOWARDS SPIRITUALISTS

The Vagrancy Act of 1824 ensured spiritualists in the United Kingdom were constantly harassed, and in the early 1950s mediums could be prosecuted as witches under the Witchcraft Act of 1735 and the Vagrancy Act of 1824. In 1951, the Fraudulent Medium Act replaced the old witchcraft and vagrancy legislation. This was a step forward for mediums, as it acknowledged that, although there might be a number of frauds, some of them might be genuine mediums acting with good intentions.

In 1944, Helen Duncan was prosecuted for pretending to communicate with the dead, found guilty and sentenced to nine months' imprisonment. She carried on with her mediumship on release and was arrested by police while holding a séance in Nottingham in 1956. Helen Duncan died five weeks later.

Sometimes the police set up people they suspected by arranging for an agent to disguise himself or herself as a bereaved person and to approach a medium for consolation. If the medium accepted the money offered, however little, they could be prosecuted.

A Natural Gift

On Saturday 11 March 1961, *The Brighton & Hove Herald* reported an interesting event. The medium Douglas Johnson addressed, at the Brighton & Hove Coffee Pot the previous Wednesday, on the subject of *The Extra Sense*, which he said should be regarded as a natural gift — a gift which some people were born with. He went on to say that some people possessed this gift, although they were not aware of it.

Many people were ignorant and had misguided ideas about the 'other world'. The trouble was that it was difficult to obtain proof in complicated psychical experiments. Douglas Johnson praised the usefulness of mediums for their knowledge of the continuity of existence beyond the physical world of space and time. It was, he claimed, a subject worthy of study by serious students.

A Few Decades Later, Interaction Between Church and Occult

A report by Madeleine Bunting, 'Priests who can deliver us from evil', *The Guardian*, 30 December 1998, focuses on the interaction between the Church and the Occult.

The report featured a Brighton evangelical Anglican priest, the Revd Peter Irwin-Clark, who spoke on the growing need for the services of an exorcist. 'There's probably been an enormous increase in the last thirty years of cases as a result of the acceptability of the paranormal in popular culture. Probably a week doesn't go by without me praying for someone to have some sort of spiritual bondage removed.' Although, officially, the Church of England and the Roman Catholic Church refuse to comment on the phenomenon, said the report, every diocese has staff that deal with exorcism, deliverance and the paranormal. The Churches face criticism that they are dealing in medieval superstition and that they should have nothing to do with it.

The Revd Peter Irwin-Clark said he'd never witnessed full-scale demonic possession but he'd experienced 'demonic affliction' by those troubled by evil spirits. 'There are considerable personal dangers to this work,' he said. In defence of his work, he cited Christ's commandment to his followers to cast out evil spirits. The Revd also believed that he had been affected by someone putting a curse on him. Finally he had a warning for the unwary. Exorcism was always a last resort as it was very dangerous. He emphasised the crossover between the psychological and the spiritual. It all depends whether you see demonic possession as caused by evil spirits or an unhealed part of the human consciousness, he explained.

The Revd Tom Willis, a Church of England exorcist for thirty years, based in York, said many referrals came from the Samaritans. 'People see apparitions, objects disappearing and re-appearing in a neighbouring room. It's not clear to me whether this is an offshoot of the human mind — some sort of stress leaking out — or it is something using human energy. I've had poltergeists reading my mind. It can be quite frightening.'

CHAPTER 21

AN APPEAL FOR AN EXORCISM AT THE SEA LIFE CENTRE

'I turned, looked up and saw a man with a hunched back. At first I thought it was my imagination but then I thought it was a ghost.'

So said Miss Anna Dziedzic, a twenty-one-year-old cleaner at the Sea Life Centre, situated just off Madeira Drive, Brighton. 'He wasn't very tall, aged about forty-seven and he was looking at the ground. There was no eye contact and it must have been for about two seconds and then suddenly no one was there.'

An article published in *The Argus*, dated 23 July 2005, told how Anna Dziedzic and several other terrified cleaners had encountered the ghost inside the auditorium of the Centre, which had been recently renovated. When Anna reported two sightings in two weeks, she'd had enough and asked her bosses if they could arrange for a Catholic priest to exorcise the frightening apparition. She explained how the first sighting had occurred, when she had just plugged in her vacuum cleaner to clean up the auditorium — it had been then that she had seen the big hunch-backed shadow. 'I was completely paralysed.'

The second time, it happened near the underwater tunnel right in the centre of the building. Anna Dziedzic explained how half her body went cold and she began to sweat. As she turned, she saw a shadow moving away from her on the left side of her body, where she had been struck with the horrible chill. She rushed to tell the rest of the aquarium staff that a ghost had just passed through her. The manager told *The Argus* that Anna Dziedzic's experiences were just two in a long list of scary encounters by a number of staff. It was agreed that a priest would be asked to perform an exorcism to bless the ghost of the hunch-backed man.

(The ghost of a Victorian woman has also been seen in the underwater tunnel by staff, and visitors have reported similar encounters, complaining she had upset the children.)

The Sea Life Centre near the Palace Pier. © Janet Cameron.

AN EXORCISM AT BEACHY HEAD BY BRIGHTON SPIRITUALISTS

People say that Beachy Head, which is notorious for suicides, is definitely haunted. Some tales tell of a sinister-looking monk who appears before people and beckons them to jump to their deaths. There are other reports, mostly from the '70s. In 1976, a man walking his dog across the Downs encountered the phantom of a woman in a long grey dress, rather like the fashion worn in the mid-nineteenth century. She moved towards them and actually stopped to pat the dog. He growled at her, his hackles rising, and then she vanished. Later, in 1978, there were several sightings of a woman dressed as a farmer's wife, complete with pinafore and a small child at her breast. She walked towards the cliff top and threw herself — and her baby — over the edge. It's believed she may have been the widow of a farmer who was murdered.

A Famous Medium Tussles with the Devil at Beachy Head

This must be one of the most sensational accounts at an exorcism in the history of the county and must have had the reading public riveted with fear and horror. Several people from the Brighton area, including from Hove, Shoreham and Peacehaven, were involved in an extraordinary and terrifying exorcism experience in 1952. The first report in *The Argus,* dated 29 January 1952, was entitled 'RIDDING CLIFF OF THE DEVIL'. The six spiritualists, led by a famous medium, believed that an evil spirit haunted the 300-foot high Beachy Head and that it was responsible for four suicide attempts in 1951 and ten others in 1949. In previous centuries, the headland may have been the site of druid sacrifices, whose influence persisted and preyed on the emotions of unhappy people seeking release from their troubles.

A comment from a Chief Inspector A. R. Seekings was non-committal. 'I have absolutely no comment to make,' he said. A clergyman thought it would be more appropriate to place some biblical texts on the headland.

However, the exorcism went ahead, according to a further report, 'TUSSLE WITH MEDIUM ON CLIFF EDGE', dated 25 February 1952. In the darkness of the headland, the medium, Mr R. de Vekey of Hoddern Avenue, Peaceheaven, prepared to do his stuff, in the company of his wife, Mr John Wallace of Hove, Mr and Mrs Len Morton of Shoreham, Mr F. Williams, president of the Hove Spiritualist Church and another man, Mr William Underhill. (There may have been more than six spiritualists as a Mrs

Wilkins apparently put in an appearance later.) All of the spiritualists were hoping to help those who felt compelled to answer the call of the evil spirit, little realising it would try to force Mr de Vekey to leap over the edge too! According to Mr de Vekey he had to grapple with the spirit — twice — when it seized him. He insisted that it was entirely visible to him.

It took the form of an elderly, bearded man in an ankle-length robe, similar to a monk's habit, with black markings on the back. He said it was in chains, and they were not handcuffs but old-fashioned wrought iron chains. 'I don't think anyone could jump from the cliff in chains like that. I imagine it was the spirit of somebody who had been bound and thrown from the cliffs centuries ago,' said Mr de Vekey, conjuring up a horrible image. His supporters stood behind him for support, praying fervently in front of wooden crosses fixed in the earth, near to where the medium and a diviner, Mr Bruce Copen, considered the influence was strongest.

Mr de Vekey was clasping another cross in his hands. He said the 'person' was waiting for the spiritualists and seemed excited and pleased they had come. The main aim of the exorcism, said the medium, was to contact the spirits of some of those who had committed suicide at the headland. 'Most of them are sorry afterwards,' he said, 'and are eager to convey their regret to relatives.'

The reporting of Mr de Vekey's dialogue with the evil spirit was disjointed. 'There is a voice calling, Oh... There is a ... being called...destroyed herself here... She is full of tears.' When the demon made itself known, Mr de Vekey cried out, 'He's calling us a lot of fools and blaspheming.' Then the evil spirit threatened to sweep them all over the edge.

'And then it began to laugh hysterically,' said one of the eyewitnesses.

The medium had to be restrained by four men as he struggled for his life close to the cliff edge, shouting, 'This thing has lain in wait for years!'

Later, Mr de Vekey explained how he had heard people praying and saying, 'God will help us' but by then he had also erupted into hysterical laughter and he could not remember what had happened after that. His friends guided him back to the car and left him there to recover, returning to hold another service.

Afterwards, to the spiritualists' amazement, there was a radiant light hovering where they had been standing, but Mr de Vekey didn't think the evil spirit had been laid to rest completely. 'To do that he would have to come right in among us and seek help.' However, Mr de Vekey felt that the evil influence had been driven away from Beachy Head.

Another spiritualist, a Mrs Wilkins, confirmed there was no interference at all when they held the second service and that everything was peaceful. 'I could have settled down on a deckchair and stayed there. It was lovely. There was perfect calm,' she explained.

IS A MANIFESTATION FROM A PAST LIFE PROOF OF REINCARNATION?

'May it not be said that we have different parts to play in different lifetimes.' These were the words of the Revd John Rowland, minister of Christ Church (Unitarian) in New Road, Brighton, as reported in *The Brighton & Hove Herald* dated 20 May 1961. His words must have seemed controversial at the time, especially coming from a churchman.

John Rowland told his parishioners that reincarnation is 'an arguable case' and that souls might reappear in new bodies. The reverend quoted the words of a distinguished Christian of the time, Leslie Weatherhead of the City Temple in London, who once said that arguments put forward about life after death could equally be applied to the concept of life before birth.

Many people claimed they could remember what had happened to them in a previous life. Mr Rowland presented the following examples:

A small boy was taken to the British Museum and was fascinated by a mummy. He told his parents about some marks made inside the mummy case, then stunned them by claiming that he had made those marks himself thousands of years ago.

A man visiting an ancient castle said he knew where there had once been a door, pointing out the particular spot. Historians proved his claim was true.

Another piece of evidence presented by the reverend was the matter of infant prodigies. For example, children who played difficult music, solved complicated maths propositions or spoke many different languages fluently at an early age.

Could all of these instances indicate forward knowledge from a previous existence? Many people believe that phobias can also be seen as evidence of previous lifetimes. Of course, there can be other explanations or sources for phobias, but is it really possible they might be due to a traumatic experience in a previous life. For example, if you have an irrational fear of drowning (aquaphobia) or of being shut up in a tiny space (claustrophobia) then this might be because you drowned or were buried alive in a previous existence. And, of course, other paranormal manifestations may be the result of some trauma suffered in the physical dimension in past times. So you could ask whether it could happen that the reincarnated might be visited by a previous incarnation of former relatives?

Is a Manifestation from a Past Life Proof of Reincarnation?

'Angry, Jealous and Earthbound' suggests that might just be the case — it's a truly bizarre story of how a man was haunted by his family from a previous life.

Angry, Jealous and Earthbound

A report in *The Argus* dated 29 March 1972 tells the story of a strange visitation from the past. Imagine experiencing a horrible spooky atmosphere in the home, a sense of being watched, strange chills and draughts and a feeling of certainty that these incidents are far from benign, even hostile. The Arnold's family home in Ventnor Villas in Hove was the venue for just such an uncomfortable visitation. The young family might never have discovered the sinister reason for the haunting had they not called in medium Mrs Gwyneth Fleet, the mother of two sons, who was also a retired nurse and a Sunday school teacher.

In desperation, Peter Arnold had publicised his plight to see if anyone would be willing to help rid the family of the ghosts and Mrs Fleet, who had been a medium for forty years, volunteered, and the Arnolds chose her out of a large number of offers. So Mrs Fleet arrived at the basement flat where Peter lived with his wife and children. Peter Arnold explained that for four years the disturbance had followed him to three different flats and he had begun to despair that he and his family would never get any peace. (An exception to the rule that ghosts, in contrast to poltergeists, usually stick to specific sites.)

Mrs Fleet said she had spirit guides to help her, including two Chinese philosophers and a Red Indian chief. So the medium prepared to do battle with the spirits in the living room, where she focused on an area that she sensed was the source of most of the activity. 'It was a most peculiar feeling that hit me when I walked into that living room,' she said later. 'It was as if eyes were following me everywhere. All the pressure seemed to be confined to one corner of the room where Mr Arnold always sits.'

Mrs Fleet was a member of the Brotherhood Gate Spiritualist Church in St James Street, Brighton, so she knew exactly what was needed. She used salt to paint an astrological five-pointed star on the wall and positioned crucifixes at strategic points around the room. Then the medium went into a trance, during which she cleared the family's auras — and discovered exactly what had been troubling the Arnolds.

A woman, a little girl, another man and Mr Arnold himself (a Mr Arnold of a former time) came to Mrs Fleet in her trance. 'I could make out that, years ago, Mr Arnold married. The woman was his wife, the child was his daughter and the man was his brother. They were in Austria during some kind of uprising. Mr Arnold was killed when he was shot in the head and the rest of the family were tortured.'

This horrible legacy, it appeared, had occurred over two centuries ago, and Mr Arnold's former family were still resentful of his present life, while his former wife was deeply jealous about his new wife. They had started a campaign to harass him. Mrs Fleet stated she had actually felt as though it were she who was shot in the head while she was in the trance. Everyone in the room felt a deadly chill, all except for Mr Arnold. Mrs Fleet said, 'I felt these spirits try to push me away, but I said some prayers and asked God to release the spirits and to help them.'

To achieve this, Mrs Fleet called up Big Chief Fleetfoot and the old Chinese philosopher, and at this point the room suddenly flooded with light. The spirits had

disappeared. With the help of her spirit guides, she was able to help the spirit family, which was earthbound, to ascend to the higher life and leave the Arnold family to live their lives like other people.

The medium explained that she had carried out several 'rescues' of this kind, and with a one hundred per cent success rate. Further, she felt that most criminals commit crimes only because they are connected to the spirits of former criminals. Mrs Fleet said she owed a lot to her guides. Once when she was ill they had helped her through it because they knew she had greater work ahead of her.

'I have got to help these people,' she said.

During, the ex-Mr Arnold had set up a highly sensitive electric beam connected to an infrared camera in the hope of capturing photos of the spirits. No reference could be found to the results of this experiment, but the family were overjoyed at the new atmosphere in the flat, which meant that they had their first good night's sleep in over four years. The strangest thing about the procedure was that not only did Peter Arnold have a 'thing about Austria' but he had also dreamt just a month before that he was shot through the head.

This is the only story in this book where a living person was actually haunted by his former self!

WITCHCRAFT — ANCIENT MAGICK

In medieval times, suspected witches were treated harshly. By the twelfth century, Christians associated witchcraft with the rejection of the scriptures and with demonic possession. Most witches were female and quite elderly, although there were also male witches known as 'warlocks'. It was claimed that witches and warlocks appealed for the intervention of evil spirits and performed diabolical rites on the Witches' Sabbath, parodying the Mass and practices of the Orthodox Christian Church. In return, the Prince of Darkness rewarded them with supernatural powers.

To test their guilt or innocence of dealing in the dark arts, the women would be 'ducked' or 'dunked', sometimes using a ducking stool hanging over a river. (There was such a ducking stool reported to have existed at Rottingdean). Sometimes the so-called witches were immersed with their thumbs and toes bound crosswise. If the accused drowned, she was proven innocent, but if she survived, then she was a witch and was burned by being tied to a stake and surrounded with faggots. Death was caused by the inhalation of smoke into the lungs, or sometimes by shock. Mostly, the victims were women and were accused because they were thought to be 'scolds' or because someone harboured a grudge and wanted to be rid of them. Sometimes, children informed on their relatives, so it could be dangerous just to correct or punish a difficult child. This situation continued up to 1736, when the law against witchcraft was repealed.

Today many Wiccans, as followers of the religion 'Wicca' are called, worship both a Horned God, associated with nature, wilderness, sexuality and hunting, and a Triple Goddess who embodies maiden, mother and crone. The God is sometimes symbolised as the sun and the Goddess as the moon. The God is also sometimes depicted as The Green Man. Some covens focus only on the Goddess, whom they see as complete in herself. The Horned God and Great Mother Goddess have been worshipped in the British Isles at least since early medieval times.

A Scientist Investigates Witchcraft

Brian Bates, a Sussex University lecturer and sub-dean of the School of Cultural and Community Studies, was the subject of an article by John Wellington in *The Brighton and Hove Gazette* dated 3 August 1979. Brian Bates said that a mysterious drug-taking, nature-loving culture existed in Britain hundreds of years ago, long before the

Lucifer, King of Hell, engraving by Gustave Doré from Danté's *The Divine Comedy*.

era of LSD. Instead, these Anglo-Saxon people used psychedelic drugs like henbane and toadstools to develop their telepathic and faith healing skills. It was only with the advent of Christianity that the sophisticated religious beliefs of the Anglo-Saxons were suppressed. While the unfortunate women were burnt as witches, the male sorcerers lost their jobs and were replaced by priests.

Mr Bates was originally a psychologist, and it was while investigating altered states of consciousness that he was led to his current research. He discovered that those who practised these ancient religious beliefs managed to change states in order to contact the spirit world. This included elves and dwarfs. During his research, Mr Bates interviewed people who took drugs and experienced for themselves the strange state of astral projection: in other words, the sense that their spirits had left their bodies and that they were flying. 'But most of the old powers have been lost,' concluded the scientist. He also added that he thought that, as a scientist, he should be open to all the data he could get.

The Hallowe'en Dance of the Brighton and Hove Witches

On the night of Hallowe'en in October 1980, a report appeared in *The Brighton and Hove Gazette*. A gathering of thirty witches, belonging to a coven called The Order of Artemis, led by the high priest of Hove, would perform naked in special Hallowe'en rites. Their ceremony would invite the dead to return to earth to communicate with them, possibly passing on messages to relatives. Images would appear in the water of a cauldron.

'One might be my father, or grandfather — unless they have already been reincarnated, of course,' said the High Priest, known as 'Herne', a fifty-three-year-old businessman and father-of-two who was reluctant to reveal his real name. 'There's still a lot of prejudice against witches. My neighbours don't know I am one,' he explained. 'We shall be raising power by means which will include dancing and sex.' But he insisted that, although there would be sex in the ceremony, it would be properly controlled. 'It's always used at the Great Sabbath to summon up power, but it's a small part of the ceremony, not a wild orgy. Witches always work naked.'

The coven included such pillars of the community as policemen, housewives and civil servants and they regarded their secret ceremony as a re-affirmation of the life force. They believed in the efficacy of spells. Recent spells by the coven had been designed to help cure a cancer sufferer, to find an unemployed man a job and to reconcile an estranged married couple. The people they planned to help never knew about the spells. Herne insisted that spells were never cast by the coven for their own advantage.

Herne didn't call his craft witchcraft, but 'wisecraft' or 'The Wicca' and stressed it should never be confused with black magic or Satanism. 'We are a nature religion and worship the old gods.' The Order of Artemis had twenty-six members including a chef, an author, lawyers and a computer scientist. That night they were to be joined by four guests from another coven, including Herne's wife, Athene.

Normally, rites would be performed outdoors, and the coven preferred a traditional sacred place like a stone circle, situated at a junction of ley lines and carrying mystic power. But the popular sites, like the Cissbury Ring and the Chanctonbury Ring were too well known by the public for the witches to use. Herne explained that farmers liked them to perform on their land because it increased fertility and one had his lamb yield increased from nine to sixty after the coven had held their secrets rites on his farm. Another farmer travelled thirty-five miles to ask the witches to use his land. However, if it poured with rain then the coven just had to perform their ceremony indoors.

The Primeval Powers of the Chanctonbury Ring

If you climb to the top of Chanctonbury Ring at midnight, you might come across a Witches' Sabbat. *The Argus* published a book review on 12 April 1973 about *The ABC of Witchcraft* by Doreen Valiante of Brighton, published by Robert Hale. Mrs Valiante, who described herself to the paper as a practising witch, told how the sacred landmark was a favourite spot for witches' covens. 'I became a witch many years ago... I have danced at the Witches' Sabbat on many occasions and find enjoyment in it. I have stood under the stars at midnight and invoked the old gods and I have found in the invocation of the most primeval powers, those of life, love and death, an up-lifting

Goya's etching, showing witches heading to a 'Sabbat', from Los Caprichos, a series of etchings produced after the painter became deaf, 1799.

of consciousness that no orthodox religious service has ever given me.' The review comments that 300 years ago, Mrs Valiante would have been burnt at the stake for making such a statement.

The most well-known legend, appearing in many sources of Sussex folklore, is that if you go to the ring at midnight and run around it several times, the Devil will appear and offer you something to eat and drink. 'A bowl of soup,' says Mrs Valiante, 'which sounds rather prosaic unless the contents of a witches' cauldron are intended.' Anyone who accepts the Devil's gift becomes his forever.

The author said it was difficult to know how many practising witches there are today (1973) because there was no central leadership, and while some covens sought publicity, others shunned it. She said we were advancing towards a new regenerated and enlightened society that repudiated the old persecution of witches. Witchcraft was a druid-like religion centred on nature worship, a belief in reincarnation, a philosophy and a way of life. Archaeologists have discovered the Chanctonbury Ring was a site of a Romano-British temple. During the 1970s, there were also a number of articles about witchcraft as a Black Art invoking the Devil and many other unpleasant practices — although none of these articles are included here. Some things are best left well alone.

Mrs Valiante was also featured in the article by John Wellington in *The Brighton and Hove Gazette* dated 3 August 1979, where she talked about the use of sex in witchcraft rituals. 'I think that young people may want to have sex at rituals. The older ones prefer not. I think we were more inhibited in my day. The world may be catching up with us,' she said. 'But in the old days they would have a great Sabbat and a terrific festival.' Mrs Valiante agreed the festivals often turned into orgies, although she was unhappy using that word.

Her initiation into witchcraft was in 1953, and to her knowledge there were three covens in Brighton, each comprising between three and thirteen witches. She added that witchcraft was older than the druids, in fact its history stretched back into prehistoric times. 'Sex is the great rite. It is a powerful form of magic — but you have to know how to handle it,' she warned.

Other sightings at Washington near Chanctonbury Ring include Caesar and his entire army, sounds of the hooves of unseen horses and phantom druids.

Witches Cast Spell on Vodafone

Mobile super-power Vodafone were bidding to put up a fifty-foot mast near to the Long Man of Wilmington, a sacred Sussex landmark, according to *The Argus* of 20 August 1999. But there were strong objections from campaigners who were determined to defeat the plan.

Kevin Carlyon, the high priest of British White Witches, said the mast would be a 'blot on the landscape' and also that it would interfere with ancient ley lines that energise the site. So the forty year-old high priest arranged for some leaflets to be printed and distributed around the village. They urged people to make their objections known by writing to Wealdon District Council. Mr Carlyon and his coven sometimes used the Long Man to act out Pagan Fertility Rituals. Now they were planning to visit the Long Man the following Thursday to cast a spell to stop Vodafone from carrying out their plan.

The Folklore of Hallowe'en

The eve of the Celtic Year was always thought to be a magical time when people could commune with spirits. The ancient festival from which the word Hallowe'en is derived was called Samheim. 'Hallow' means to bless and sometimes the festival was called the Eve of All Souls' Night, All Saints' Day, Hallowtide or Hallowmass. People thought they needed to protect themselves from evil spirits on this night and kept all their doors and windows shut. They also left food and drink out for fairies, so that the tiny spirits would leave blessings rather than evil tidings.

Even animals had to be protected from the sinister goings-on of Hallowe'en, and so stables and other animal accommodation were candlelit to keep away harmful entities. It was believed that Hallowe'en was the final opportunity for the dead to commune with the living before the onset of the icy winter season. If people had to travel outdoors on Hallowe'en, they'd take with them some bread and salt. Salt, especially, was repellent to witches. (Meaning the bad witches, and not the well-intentioned white witches like those in the story above). Also the Rowan tree, with its magical properties, was used for making a cross to carry as a talisman.

The Water Witch of Davigdor Road

The skills of water diviners — occasionally described as 'water witches' — have been the source of a hot debate for many decades. Are their skills genuine or not? According to *The Brighton and Hove Herald* of 28 July 1928, a water diviner, Major C. Pogson, was employed by a Brighton company to check for a water supply in Davigdor Road. Major Pogson was highly-esteemed in India for water divining and held the official post as water diviner to the government of Bombay. Allegedly, he'd surveyed 577 sites, ascertained that 357 had no water but had a positive finding on the remaining 220 sites. Of these, only two failed to produce water.

Waterworks engineer, Mr A. B. Cathcart, and the newspaper reporter accompanied Major Pogson in an excursion to the Downs to conduct an experiment. Apparently this was a challenge as the ground is chalky, unlike India's thirsty soil. Major Pogson disdained using a forked twig, saying it was 'nothing' since all it did was show what happened to the hand of the diviner. Instead, he held in front of him a piece of steel like a long knitting needle, and he told the other two men that if water was located, the needle would pull downwards.

Major Pogson found a certain spot, which he passed over several times, registering a strong pull from below, which led him to believe water was present at 180-220 feet. Mr Cathcart also had a try, with a similar positive response. But the reporter was still unconvinced. When he tried, he felt no response at all. He was a self-confessed sceptic so it's possible he lacked the faith necessary to respond fully to the earth's energy.

PSYCHIC SURGEONS AND OTHER MIRACLE HEALING PHENOMENA

These stories span the ages, the first dating from the mid-eighteenth century and the last, just a few years ago. Adherents to faith healing believe that we all have healing abilities within us. The principle is that human beings are energy and so is everything else around us. Belief in the power of healing often seems to be highly effective — and whether this is a supernatural force at work, or the equally impressive ability of the human mind to be healed through faith, is really arbitrary. In principle, it is simply a matter of mind, body and spirit, all of them working together in perfect harmony.

The Power of the Gibbet

An old lady was comforted to her dying day by the power of the gibbet.

She lived in the village of Wivelsfield on Ditchling Common. An inn, the Royal Oak, was the site of the murder of three people, as reported in *The Brighton & Hove Gazette* of 9 July 1965. After committing this terrible crime, the perpetrator, a pedlar called Jacob Harris, went on to rob the house of the victims. Jacob was hanged at Horsham in 1743 and afterwards he was suspended from the gibbet on the Common as a lesson to other rogues and vagabonds. The gibbet was named 'Jacob's Post' by the locals and, later, when a new post was erected it inherited the original name.

At the time, it was believed that if you kept a piece of the original post on your person, you would never get toothache, a scourge in the Middle Ages long before dentistry when the only anaesthetic was to get blind drunk before 'treatment'. This particular woman had complete faith in this special magic. 'She was still carrying a piece of this enchanted wood when she was well past 80, and long devoid of any tooth to ache,' concluded the report.

Chevalier Taylor, Occultist for Distemper of the Eyes

The Sussex Weekly Advertiser of 24 August 1761 carried an advertisement for a celebrated occultist who claimed to cure eye disorders. Chevalier Taylor was occultist to all the crowned heads in Europe, as well as a citizen and a noble of Rome. 'The poor afflicted in the Eye may have his best assistance free and the faculty and gentry invited to be personal witnesses of his present method of restoring sight,' said the advertisement.

An old engraving of a man being 'gibbeted'.

Chevalier Taylor travelled around Sussex, starting at the White Hart in Lewes at 11 a.m. on Saturday 17 August. Then the Chevalier visited the Castle in Brighthelmston and Chichester before travelling to Shoreham-by-Sea to have his dinner in The Star. From there he was to visit Arundel and then proceed to Oxford where he was to give lectures on the art of restoring sight.

A New Lease of Life

Thanks to a psychic surgeon, a couple living at Queen's Park, Brighton, were about to enjoy a new lease of life. *The Argus*, dated 14 March 2000, told how John Burdock, aged fifty-three, suffered from serious stomach pains for two years. Conventional medicine was unable to help despite an operation at Brighton General Hospital. John wasn't eating properly and was losing weight. 'Just to touch me was agony. I did not want to live,' said John.

So John and his wife Frances, both in their fifties, called in Ray Brown, who was formerly a bricklayer. John needed treatment for his chest, arms and legs. Ray claimed to be possessed by the ghost of a 2,000-year-old surgeon called Paul. Mr Brown, confident of the spiritual help of Paul, laid his hands on John's stomach. Over five sessions, the pain was reduced to an ache, and then that too gradually disappeared; John Burdock was completely healed.

The Power of Magnets

An article by Lisa Frascarelli appeared in *The Argus* dated 23 June 2006 about a woman who was cured of her blindness — by magnets! The paper commented that American scientists had researched the healing effects of magnetic attraction and found no evidence to support it. So the woman from Hove told *The Argus* about her own experience. Eleven years previously, Val Dargonne was diagnosed by doctors as going blind due to the degenerative eye condition Retinitus Pigmentosa. The doctors told Val Dargonne that there was nothing more that could be done for her.

Val Dargonne explained: 'I was suffering with peripheral vision problems and night blindness.' Being told that it was incurable and that she was just a couple of years away from losing her sight altogether was more than she could bear. 'It was a shock... I didn't want to think about it so I just carried on as normal,' she said, and so she continued to practise as a remedial massage therapist in Hove. Then, she says, she 'stumbled upon magnet therapy' and so she decided to take the treatment. She started to feel her sight was improving, so she invested in a powerful electro-magnetic machine for her clinic. It wasn't long before she decided to try this new machine out for herself.

'With one treatment I suddenly realised I could see the horizon again.' This was in the evening, when her ex-husband was driving her, and she was so stunned she got him to stop the car so she could step outside. 'For the first time, in a long time, I could see the stars.' he was convinced her recovery was entirely due to the electrocmagnetic therapy, which makes the body's own electromagnetic energy function more effectively. She continued with the treatment and her eyes continued to get better.

When she went to the optician, her test showed a great improvement in her peripheral vision. 'The treatment just seemed to really work for me,' she said, and then she wholly disputed the claims by two American scientists who'd been quoted in the British Medical Journal as saying there were no benefits to be had from electromagnetic therapy.

CHAPTER 26

STRANGE ORBS... OR ALIEN SPACECRAFT?

Before the term UFO (Unidentified Flying Object) was created by the United States Air Force in 1952, these strange objects in the sky were known as *Flying Saucers*. According to a report in *The Argus* of 10 October 2007 recently published Ministry of Defence figures amounted to fifty-two UFO sightings over Sussex between 1998 and 2006.

The MoD have to investigate them all in case they can be attributed to unauthorised military or hostile activity. 'If required, sighting reports are examined with the assistance of the department's air defence experts. Unless there is evidence of a potential threat, there is no attempt to identify the nature of each sighting reported,' said an MoD spokesman, as reported in *The Argus*.

Some sightings are attributable to hoaxes, but there are people who claim these are a very small percentage of the total. Most of these sightings — or according to some reports up to thirty per cent — are truly UFOs: in other words, experts are unable to identify them as belonging to the known world. Whether or not they are actually aliens from another world is still up for debate. One thing is for certain: that these sightings have been going on for quite some time and have been witnessed by lots of people, many of whom sincerely believe, 'We are not alone'.

Could it Really be Aliens?

The Argus of 17 November 1953 reported that a number of people had witnessed a mysterious light moving across the sky over Brighton the previous night. Here are some of their comments, as reported in the paper:

Patricia Hart, aged 16: 'I was walking on Ditchling Road at about seven o'clock when I saw a reddish blue object in the sky to the west.'

Mrs Gladys Cregan: 'I was putting my daughter to bed when she said, 'Look at the light in the sky, Mummy!' I looked out of the window and saw a bright light with sparks shooting from it travel over the sky in the direction of the Downs, north of Shoreham. It was travelling quite slowly at first. Then a flaming object detached itself from it and spiralled earthwards. Then it vanished over the horizon.'

A Hove Woman (unnamed): 'It seemed to be a magenta colour and was swinging to and fro like a pendulum. It was over Brighton when I last saw it.'

An alleged flying saucer photo published in US in 1952.

The Saucer Debate

In the 1950s, there was a great deal of debate going out about what these strange objects in the sky could possibly be. *The Argus*, dated 2 November 1953, published a letter from L. R. E. of Shoreham pointing out that spaceships were seen 300 years ago. L. R. E. wanted to look at the debate 'from a sane point of view'. Firstly, regarding these 300-year-old sightings (350 years at the time of writing), this was long before the existence of aircraft, so these UFOs cannot be attributed to aviation. He also pointed out that at one time people would not have believed the VI or V2 rockets were possible; air speed faster than sound would have been the dream of a maniac. (What would L. R. E. think of our modern-day technology?)

'It is almost certain that people do exist on the planets,' s/he says, 'and if so, who are we to judge their capabilities? They may be hundreds of years in advance of us and interplanetary travel may be easily within their scope. I have no doubt we shall have definite evidence of this within the next twenty years.'

Well, that prediction was clearly rather optimistic but, even so, L.R.E. made another good point. He, or she, believed that reports of UFOs were filed by the authorities without comment and asked if this was because excuses made previously proved impossible and no new ones were forthcoming. The following, although recently reported, is claimed to have actually happened in the '50s.

Roswell at Withdean?

The Argus of 3 March 2008 published a letter from Mr John Hanson of Alvechurch, regarding a phenomenon that occurred at Withdean in the early 1950s. The incident was claimed to have happened to a Sheila Burton, who lived in Withdean with her family. At the beginning of September in 1951, Mrs Burton had woken at 6.30 a.m. and was looking out of her bedroom window when she claimed she saw a large flashing object in the sky. It descended at an alarming speed onto the lawn of her back garden.

As three square-panels in the object opened, three five- to six-foot tall 'men' appeared. Mr Hanson reports Mrs Burton's description. They had 'bald heads, odd expressionless faces, small pointed noses and ears, no lips and deep-set eyes.' Dressed in dark green or khaki one-piece garments, their movements were robotic, and they appeared to be carrying what looked like a weapon, which was similar to a machine gun. After their brief reconnoitre, they got back into the craft and it shot vertically into the air and sped away.

Amazing Spectacle at Woodingdean

A housewife was looking out of her bedroom window, from her home high up on the Downs at Woodingdean, when she saw an amazing sight and was convinced it was an unidentified flying object. According to *The Brighton and Hove Herald*, dated 12 December 1969, Mrs Doreen Williams of Bexhill Road saw the object around dusk the previous Thursday.

'It was a rather dark object, longer than it was broad. I went on with my work, but when I looked out again a few minutes later, it was still there,' she told *The Herald*.

Her children joined her to watch the phenomenon and they were all very excited. 'After about ten or fifteen minutes, it started to move and, at the same time, an orange glow came from the tail.'

The object began to move slowly inland towards Brighton and appeared to be climbing. Mrs Williams said it looked like a picture of a comet and the orange glow from the tail was three times the length of the dark object itself. 'It was very vivid,' she said.

Definitely Not Meteors!

According to a report by Andy Dickenson in *The Argus*, dated 27 November 2006, James Gordon-Johnson of Preston Park Avenue, Brighton, aged thirty-three, was out for the night with his brother. On leaving a Shoreham restaurant at around 11.30 p.m. on the night of 18 November, the two young men saw a 'very big orange light in the sky.'

What was strange was that the object wasn't moving, and it just seemed to be suspended in mid air. Then another similar object appeared, and it seemed to be hovering over Hove Lagoon. Other people reported seeing the phenomena and all emphasised the extreme brightness of the orbs. Mark Sztoepl from Brighton insisted, 'I can tell you these definitely weren't planes.'

Shoreham Airport said people had been in touch to enquire about the UFOs, but unfortunately the airport had already closed by 7.00 p.m. Meantime, the plot thickened when a man phoned the police to say he'd spotted eight planes coming in to land at Gatwick with no flashing navigation lights. The objects appeared in a perfectly straight line. Gatwick Airport had no knowledge of these planes, although they suggested a meteor shower might have been responsible for the spectacle. But Mr Gordon-Johnson disagreed, because the objects were too big, too bright and too low to be meteors.

Four Orange Orbs Over Shoreham

Four orange UFOs were spotted sailing from the south-west over Shoreham by Ian Thornton of Second Avenue, Hove. Ian's strange sighting was reported by Andy Dickenson of *The Argus* on 14 March 2007. Ian Thornton described how all the UFOs were travelling at the same altitude and moving at the same speed, in the same direction. 'They were lower than the usual aircraft.'

Ian Thornton wasn't the only one to spot the strange phenomena and a number of people reported similar 'lights and orbs' in the area.

An Orb Floats over Hove Park

What, exactly, was the strange object floating over Hove Park?

According to a report by Andy Dickenson for *The Argus* dated 14 March 2007, there had been two separate sightings of UFOs over Sussex. The previous Sunday, around 1.30 p.m., people were amazed to see a flickering, silver craft floating over Hove Park, the night after four orange orbs were witnessed over Shoreham (see 'Four Orange Orbs Over Shoreham' above)

Some spectators were convinced the spectacle was attributable to alien invasion, while others thought it was all a hoax — one using Chinese lanterns. Stewart Hall, an artist who lived in Holmes Avenue, Hove, asserted that what he saw was no hoax. 'It had no wings or windows and appeared to be a tubular shape.' Mr Hall managed to take a photograph but it did not do justice to what he had seen. The craft, he asserted, was much larger than the image he'd captured on film.

An Invasion of Aliens?

A further report in *The Argus* dated 10 October 2007 said that 'masses of mysterious red lights have sparked another UFO riddle'. Sixty glowing orbs were hovering above Uckfield the previous Saturday night and locals believed the town was about to be invaded by aliens. One young man, Jamie Smith, said, 'My dad said to come out into the garden and it was the most amazing thing I've ever seen. There were at least sixty of these lights right above us, all in close formation. There was no way they were planes or anything like that. Then they moved off and only two remained, then they too disappeared.'

Stephanie Gibb also observed the lights. 'It was creepy,' she said, 'but brilliant.' *The Argus* reported that numerous other lights had been observed over Brighton, Chichester and other parts of East Sussex.

Hazy Spotlights

According to reports, restless spirits haunt the crossroads at Handcross. One woman claims to have seen three 'spotlights' travel across the road. These were not headlights as there were no cars around at the time. Also, a ghostly shape appeared behind the spotlights.

Fast-Moving UFO Over Downs

Yet another UFO was reported 'zooming across the Downs near Lancing' by Michelle Huggett in an article in *The Argus* dated 3 January 2008. This one was red and orange and was not in any way behaving like an aircraft. It made no noise; it just moved very fast and then suddenly stopped.

Could all these eyewitnesses have been dreaming?

THE MYSTERY OF CROP CIRCLES

Everyone seems to have a theory about the emergence of crop circles, but no one seems to be able to prove where they come from. Some think they are the result of alien invasion. Certainly, people may have 'jumped on the bandwagon' and produced elaborate hoaxes, and — human nature being what it is — that is more or less inevitable. But are they all hoaxes? Plenty of genuine and honest people believe differently.

Tongues Start Wagging

Some mysterious corn circles first appeared in a field near Alfriston in 1984 and then another occurred in 1986, exactly two years later. According to *The Argus* dated 10 July 1986, tongues started wagging when the circles appeared in the middle of a field of corn in Rothfinny. No one could imagine where the circles had come from or what they actually were. People asked if extra-terrestrials had made a second visit to the field or whether there was a more rational explanation, 'like an earthling with a wicked sense of humour'.

The farmer, John Mossop, was anxious to dispel the rumours of UFOs, especially after the previous 'visitation' and the stampede of sightseers that had overrun and trampled his land. However, a Brighton weatherman confirmed that mini-whirlwinds were most unlikely to be the cause of the circles.

The Argus published an article on 4 June 2003 entitled 'Crop Circles a Hoax, Say Experts.' But it wasn't quite as straightforward as that. Apparently crop circles had appeared in fields between Lewes and Ringmer, and, although these were deemed to be hoaxes, the experts couldn't explain other recent discoveries at Woodingdean and Sompting the previous Sunday. Two experts, Andy Thomas and Allan Browne, had inspected and analysed some of the circles as well as an additional crudely-shaped star. Sometimes the formations were messy and the men could see where a foot or plank had been used to flatten the corn. You would not get these secondary breakages in a genuine circle.

But another circle was discovered in the same field that the experts believed to be genuine. Likewise, the Woodingdean crop circle was also claimed to be real, as it was so complex it could not have been produced as a hoax. Allan Browne said, 'I have studied crop circle designs every day for the past five years and I still learn something new every time. The geometry used is so far reaching — it really has been my best teacher. It makes

me realise it can't possibly be drunk people doing it for a laugh. There is no way you can just go into a field and draw such geometrically complicated shapes overnight.'

According to Allan, it appears as though the corn has been exposed to heat because the seed head is found to be mutated, its growth rate altered and the cells swollen. Andy has written books on the subject if you wish to study further, for example *Fields of Mystery* and *Vital Signs*.

Today, the authenticity of crop circles is still being hotly debated, as circles of increasing complexity are found all over the world. Although some crop circles are probably hoaxes — in fact, some pranksters have owned up to being the culprits — it's still difficult to see how people could create such complex and intricate geometrical patterns in the middle of a field, in a few hours and in the dark.

Dan Vidler, who took this photograph of a crop circle that appeared between Lewes and Ringmer on 29 April 2005, says, 'Apart from it's striking simplicity, the main notable feature of this crop circle is the large area of standing crop at its centre. There is no evidence of these stems having been disturbed, no entry points from the ring itself, and no apparent damage to the crop.' In view of Dan Vidler's analysis, it would seem impossible for this beautiful circle to be the work of a practical joker.

While some people believe the crop circles are created by UFOs or alien spaceships, another explanation is that they are the result of 'ball lightning', which is claimed to be an atmospheric electrical phenomenon. These may be luminous objects, maybe very small or much larger. Unlike lightning associated with thunderstorms, which manifests in a brief flash, ball lightning is said to last for several seconds.

Another theory asserts that crop circles can be created by orbiting satellites through Masers (Microwave Amplification by Stimulated Emission of Radiation). It's claimed that satellites controlled by humans would have the technological capacity to create such designs by computer. Whatever the provenance of these beautiful formations, they are the source of a great deal of wonderment.

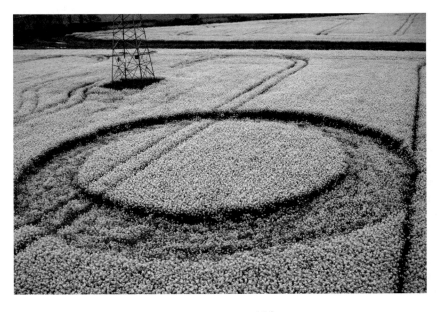

An impressive crop circle in a field between Lewes and Ringmer, photographed on 29 April 2005 by Dan Vidler ©

CHAPTER 28

SOMETHING SINISTER IN THE LOFT

It's seldom that a spirit or ghost is reported as having physically attacked a person, but the following story of a terrifying encounter in Newhaven contradicts our conventional understanding of what is a ghost. For the young woman who experienced this horrific episode, it will never be forgotten.

Elle mentions that her stepmother was always convinced the house had spirits. But she had always been sceptical with people who claimed to see ghosts. 'I always thought it may well be true, but so many people make things up, I found it hard to sift through to find the genuine stories of real encounters,' she says. That is, until the following frightening encounter that occurred in her house in Newhaven, a town just outside Brighton, about six years ago when she was seventeen.

It was mid-summer and a boiling hot day. Her family were out and she was alone in the house with her boyfriend. Earlier that day, Elle's dad had asked her boyfriend to put some stuff in the loft for him. Later, Elle remembered that her boyfriend had left the trapdoor open. Possibly this was the catalyst for what happened next.

Her boyfriend was bored and he decided to go into town to rent a film and buy some food for lunch, but Elle preferred to stay home. So, alone in her house apart from her pets, the young woman lay on her bed, playing with her new kitten, a tiny silver tabby, while the border collie, Willow, lay asleep on the landing outside her room. Willow knew that she was not allowed in any of the bedrooms.

Elle lay back on her bed and placed the kitten on her chest. Then she heard boots clumping on the stairs. She wasn't alarmed as her boyfriend sometimes wore big workman's boots, so, thinking he'd forgotten something, she glanced towards the door. No boyfriend appeared. But the dog suddenly came flying into her room, whimpering and cowering by the bed. Surprised, Elle sat up to try to comfort the distressed dog.

A hand seemed to press over her eyes, pushing her back. Shocked, but no longer believing it was her boyfriend, Elle began to scream. 'This isn't funny. What are you doing?' She struggled as hands went around her neck, almost chocking her. 'Please don't hurt me, please don't hurt me,' she cried, over and over.

After a few seconds, the pressure eased and she lay there for two or three minutes, then she opened her eyes — and there was nothing there. Breezer, the kitten, was still on her bed, spitting and with all her fur standing on end, and Willow, her dog, lay by her bed without making a sound, her body flattened into the carpet as though she was trying to make herself invisible.

Elle phoned her boyfriend's mobile and he took a cab back immediately to find her crying and distraught from her frightening experience. Together they looked, disbelievingly, in the mirror in the bathroom, at the huge red finger marks on her neck. The bruises took several days to heal and faded into a deep purple-coloured bruise. It was difficult explaining to her concerned father that it wasn't her boyfriend who was responsible for the bruises — he wasn't even in the house.

Elle still has no idea what really happened or why it happened, all she knows is that she was terrified and speculates that maybe something sinister was disturbed by her boyfriend when he went into the loft, something so deeply disturbed that it wanted to wreak a horrific revenge. 'I'm not looking for a definite answer as I expect I'll never get one, but that's ok,' she says.

'I don't believe it was evil,' she adds, generously, 'maybe just messed up.' Whatever it was, it seems it had escaped to attack Elle when her boyfriend failed to close the trapdoor.

CHAPTER 29

FORTUNE TELLING AND PREDICTION

Fortune telling is an ancient practice and, like witchcraft, has been resisted in previous centuries by the Church and by civil laws. In fact, it was seen as a form of witchcraft, and in a statute of 1563, in the reign of Queen Elizabeth I, fortune telling invoked the death penalty. In 1735, King George II (1683-1760) reduced this harsh sentence to one year's imprisonment and a spell in the pillory. King George ordained that anyone claiming occult skills and telling fortunes could be imprisoned for one year after being placed in the pillory. Later, the horrible punishment of the pillory was abolished by George IV (1762-1830) and fortune tellers were lumped in with vagrants, rogues and vagabonds, and could be imprisoned for three months. Fortune telling ceased to be an offence unless fraud was involved. Around the time of the story below, the country's fortune tellers were still being treated as rogues and vagrants.

An Eighteenth-Century Scam

According to the *Sussex Weekly Advertiser* dated 15 June 1749, a maidservant to an eminent tradesman was duped out of four pounds, four shillings and sixpence by an incredible stratagem. The story was published because 'incredible as it may seem, [it] may be depended upon as a Fact, and which we are desired to insert by Way of Precaution to others,' cautioned the paper.

Apparently, a tall, thin woman of a brown complexion and wearing a red cloak, straw hat and light-coloured gown came for the servant, informing her a spirit would haunt her as long as she lived — if she did not do as she bid her. This was to fetch all the money she had and wrap it in a piece of paper, and then lay it by for three days. If she did this, the same spirit had ordered the woman to direct the maid to where a large sum of money was hidden beneath her master's house. The woman told the maid she was the lucky person 'pitch'd on to find it'.

'The silly Creature,' says the paper, 'thro Fear and tempted with the Gain of great Riches, went and fetched the above Sum, which, as soon as she had wrapped it in papers, the Cheat found means to exchange it for another with only four halfpennies in it.' At the end of three days, the cheating woman had not returned, and when the maid went to examine her money, 'she found she was tricked, to her great Mortification'.

The Truth of Her Art

The Sussex Weekly Advertiser dated 11 May 1751 reported a trial of a man bound over for beating a woman. In revenge, the man said that the woman pretended to tell fortunes, contrary to the Vagrant Act. The woman was arrested and brought to justice, but the man wasn't there because he was having his dinner. Before he was ready to examine her, she vanished — in other words she escaped in 'so extraordinarily a manner that she hath greatly convinced the Mob of the Truth of her Art, tho' perhaps she had only learnt the method of crossing the Hand, a ceremony always used in fortune telling.'

The definition of 'crossing the hand' according to the *Dictionary of Phrase and Fable*, E. Cobham Brewdf (1894) is as follows: fortune tellers of the gipsy race always bid their dupe to 'cross their hand with a bit of silver'. This, they say, is for luck. Of course, the sign of the cross warded off witches and all other evil spirits, and, as fortune-telling belongs to the black arts, the palm is signed with a cross to keep off the wiles of the devil. 'You need fear no evil, though I am a fortune teller, if by the sign of the cross you exorcise the evil spirit.'

Fortune Telling at St Ann's Well Gardens

St Anne's Well Gardens became a public park in 1908, thanks to Dr Richard Russell who first recommended seawater as being beneficial. He added that the Chalybeate spring on a little hill in Hove contained iron and would do people good. That little hill was St Anne's Well Gardens, reports *The Argus*, dated 12 May 2008.

In the 1880s, St Ann's Well Gardens were improved with a children's playground and adult musical events. A fortune teller called Gypsy Lee worked there from her caravan for around fifteen years. She made a prediction that the coronation of Edward VII would not take place and she was right: the royal event was postponed due to the future king's appendicitis. It was claimed Gypsy Lee advised Prime Minister William Gladstone, although *The Argus* points out there is no confirmation of that.

A hypnotist/illusionist called George Albert Smith ran St Ann's Well Gardens for some years and worked there from his own film studio during the 1890s.

Madam Eva Petulengro

One of Brighton's most famous clairvoyants was Madam Eva Petulengro, who was a popular tourist attraction on the Palace Pier during the '60s. According to an article in *The Brighton and Hove Gazette* dated 24 August 1979, Eva Petulengro was most famous for predicting Albion's promotion, Princess Ann's marriage and the assassination of President Kennedy. Impressive! Her daughter was also called Eva Petulengro and her granddaughter is Claire Petulengro, who has made a name for herself as an author and also as an astrologer to several well-known publications.

According to the official website of 1960's singing sensation Kathy Kirby, the star's fortune was read by Eva Putulengro in 1970, while she was in Brighton for the summer season. During the show, she visited Eva Petrulengro and the clairvoyant predicted that Kathy's manager and partner, Bert Ambrose, would be dead within twelve months. Sadly, she was right. Bert Ambrose died the following year in June.

Right: The Romany clairvoyant's consulting room on Brighton's seafront. © Janet Cameron.

Below: Sunset taken from the seafront walk at Ovingdean near Brighton. Ghosts are — so some people say — likely to appear during sunset. © Janet Cameron.

Not 100% Foolproof

The Brighton and Hove Gazette dated 26 September 1980 ran a short report headed 'Crystal Clear'. A fortune teller had been booked for Ovingdean village fête the previous week, but she failed to arrive. The organiser said the reason was unforeseen circumstances!

Long Life for Louisa

The Brighton and Hove Herald of 21 November 1969 reported that Mrs Louisa Mason of Ashton Rise would be 100 years old the following day. Louisa expected no less, as a palmist had read her hand and, observing her long lifeline, told her she would live to a great age. The old lady outlived her two daughters, who both died in their seventies. She had lived in Brighton for fifty years, having moved here from Margate, and still cooked her own lunch.

The Power of an Egyptian God

A teacher, Gayle Evans, visited tarot reader Paul Hughes-Barlow when she came to Brighton for a fun day out. According to *The Argus* dated 4 June 1999, Paul told the twenty-four-year-old Liverpudlian's fortune using a Thoth Tarot deck. (Thoth was the Egyptian God of learning and knowledge.)

The consultation took place in Paul's small office under the Palace Pier. Paul, who'd had ten years experience of tarot, palmistry and astrology, used the Opening of the Keys card layout for Gayle and turned up the five and seven of coins and the moon card. This wasn't good. It warned of financial loss, mishaps and deception, and Paul, feeling terrible, apologised to Gayle for the bad news.

But the speed with which Paul's warning came true even amazed the fortune teller himself. A few minutes later, when Gayle was sightseeing in The Lanes, a thief seized her purse and escaped with his booty — Gayle's precious £85 spending money.

Immediately Gayle reported the theft, and even the CID crime desk assistant could not believe it. 'I've heard some strange stories in my time but never one like this,' he said.

The irony was that before this happened Gayle was a total sceptic. She had not believed in the power of the tarot cards and was only having her fortune told 'for a bit of fun'.

A Double-Win

On 28 May 2004, *The Argus* published the story of Mystic Meg's prediction that Brighton and Hove Albion would triumph over Bristol City. Mystic Meg was dining at Gordon Ramsay's Hell's Kitchen restaurant with, among others, the Brighton tailor Gresham Blake. The psychic gazed into the glass lamp on her table and immediately saw a vision of seagulls on a green field. This was very good news because it represented victory for the Brighton and Hove team.

An Egyptian God.

Later, Mystic Meg told *The Argus*, 'As soon as I saw him, I had a picture of him celebrating Brighton's victory at the Millennium Stadiam. I had a very positive feeling towards Brighton and was sure they would win.'

Great Oaks from Little Acorns...

According to *The Argus* dated 5 May 2005, a magician, Lee Hatt, claimed to be able to predict the newspaper headlines days in advance. The stimulus for his gift was being presented with a Paul Daniel's magic set for his birthday when he was eight years old and it had all gone on from there. Lee Hatt was confident enough about his skill to have his predictions placed in sealed envelopes in advance of the date of the forthcoming front page. He said he was usually not one hundred per cent accurate, but eighty to ninety per cent right, which seems pretty convincing odds.

On 10 May, *The Argus* published the result. The night before the show, *Totally Mental*, at The Fringe in Kensington Gardens, Brighton, Lee Hatt, who lives in Wykeham Terrace, wrote out his prediction and sealed it inside three signed envelopes. *The Argus'* reporter popped it into the safe. On the night, when the envelopes were opened on stage, the prediction was that yesterday's front page would read 'Midnight heroes.'

The headline actually read 'Heroes of a magic night', a slight variation in sentence construction but in all other respects spot on!

CHAPTER 30

DEVIL'S DYKE AND THE ROAD GHOSTS

These stories that don't fit into the previous chapters, so we have ended up with a combination of old and new, on the one hand the legendary and almost epic account of diabolical activity around the Devil's Dyke, and the rather sad little stories of small girls, thought to be victims of road disasters:

The Devil's Dyke

Many stories are rooted in legend and are now part of Sussex folklore. The beautiful blue scabious flower is known in Sussex as the 'Devil's Bit' because it was believed the devil had bitten off the root, to destroy its health-giving properties. At Devil's Dyke, it was claimed a footprint was found with four toes. It was twice the size of a human print and, reputedly, that of Old Nick himself. There are two main versions of the legend that the Devil created the Dyke.

Legend 1
This is probably the most famous account. The Dyke is said to be the work of the Devil, who 'plowed out' a huge V-shaped trench to flood the area and destroy all the churches. Meantime, an old woman heard him at his dastardly task and she lit a candle. A rooster, thinking dawn was breaking, began to crow. So the Devil also believed dawn was breaking. He could only complete his task in darkness, so he disappeared, presumably back to the darkness of hell, to escape the hated daylight. Thus the Devil left the trench unfinished.

Legend 2
The Devil donned the disguise of a goat with the purpose of crushing the area, but when he smelled salt water in the wind, he was worried his fine coat might get spoiled from the damp. So, again, he fled and left his footprint — The Devil's Dyke.

Scientists, however, claim that Devil's Dyke was formed in the ice age.

Ditchling Beacon's Terrible Trio

The third-highest point on the South Downs and the highest in East Sussex is Ditchling Beacon, a large chalk hill to the north-east of Brighton. There are many legends about the Devil's activities in the region. In the first half of the twentieth century, shepherds reported that they had heard the witch hounds' demonic baying overhead, accompanied by horses' hooves and the horn of the huntsmen. The task of this terrible trio was to hunt the souls of the damned.

Smugglers, those great exploiters of circumstance, used many of these stories to protect themselves from capture, when landing their cargo or storing their goods. Sometimes, the customs men were aware of this trick and braved these allegedly frightening places only to find a large cargo of goodies left there by the wily smugglers.

Chanctonbury Ring

If you go to Chanctonbury Ring, says local legend, and count all the trees, you will raise the ghosts of Julius Caesar and his army.

A Benevolent Spectre who Loved Soldiers

On 28 August 1986, *The Argus* carried a strange report about a ghost that appeared before Canadian soldiers billeted at Fulking, a small village the other side of the Devil's Dyke. This little village comprised thatched houses and flint cottages and was much loved by scholar and patron of the arts John Ruskin. In 1931, only 182 people lived there; 50 years later there were 259 inhabitants. In a 1986 article, just 100 householders were recorded. It's claimed that at the time of the Black Death in 1665, people actually fled to Fulking for sanctuary from the disease.

Old Farm House, where the haunting occurred, was originally a manor house built by a Norman baron in the twelfth century, Baron de Falke. The Canadian soldiers billeted at Old Farm House reported the ghost of a little white-haired old lady. She was always dressed in black and carried a Bible. She only ever showed herself to those whom she wanted to protect. She certainly protected the young Canadians: all seventeen of them later served in Italy and all escaped 'without a scratch'.

The Apparition of a Young Girl in Red Scares a Driver

A man spotted a young girl in a red coat on a main road, first between Handcross and Crawley and later the same day near Brighton. Mr P. H. Leggatt of Nesbitt Road, Brighton, was so freaked out by the incident that he wrote to *The Argus*. His letter about the sighting, which happened on 29 January 1975, was published on 4 February that year.

'What I saw seemed very strange indeed as the figure seemed to be moving — without any bodily movement,' he said. 'I was very disturbed because I felt what I was looking at was not human, although it took place in the middle of the day.' The sighting near Lewes

was on his outbound journey, and the one near Brighton happened as he returned home. He asked if anyone else had seen such an apparition, but the author was unable to locate any replies in future *Argus* postbox features. It's claimed, though, that motorists have encountered the girl in red and have pulled over to offer her a lift, but in every case she then vanished.

There have been other sightings on the A23 just north of Brighton. This time it's a young girl with blonde hair and wearing a raincoat. She tends to limp. In 1964, a driver claimed he saw this spectre run to the middle reservation and then vanish. Then, again, in 1972 people who lived in Pyecombe claimed to see her. A woman in her forties reported seeing a male phantom near Handcross who appeared behind three bright lights.

Animal Ghosts

A white dog is reported to haunt a road from Alfriston to Seaford, and it appeared on the eve of midsummer every seven years. The legend was that it would bring death to anyone who saw it. It's claimed the dog belonged to a young man who was murdered by robbers in the eighteenth century and that the dog was also killed by the murderers. When the road was widened in the nineteenth century, both skeletons were found during the excavations. The young man's body was thought to be that of a son of a local, well-to-do family. After its master's body had been laid to rest, the seven-yearly appearances of the white dog stopped.

CHAPTER 31

LUCKY STONES

I hope you have not been too fazed by these scary stories of spooks, poltergeists and things that go bump in the night. But if you have the slightest creepy feeling, then take yourself down to the beach and find yourself a lucky stone. These are also sometimes known as hagstones, holy stones, holey stones, nightmare stones, wish stones and witch stones, and they are made of flint. Some people even call them 'pregnant pebbles'.

Lucky stones are easy to recognise and our Sussex beaches are, reportedly, a good hunting ground for them. They are the round stones that have a hole running right through the middle, a bit like a huge flinty polo mint. There are several explanations about how the holes are formed, and some people say it's just the sea wearing a hole through them. A likelier explanation seems to be that they have an inherent contamination formed millions of years ago, for instance a sliver of wood or a dead sea-creature that has fossilised inside the stone. The stone wears through erosion, and the contaminated particle causes a weak point, which eventually leaves the hole.

Lucky stones are believed to have magical properties that protect you from harm, warding off misfortune and bad vibrations, witches, the devil, the evil eye — in fact, just about everything nasty. If you thread fourteen stones together, you will be especially well protected — that is, if you're lucky enough to find that many.

The belief is that magic (i.e. bad magic) can't work on running water, and because the stones have been subjected to running water, they gain this special quality of protection. They are supposed to prevent milk from curdling and farmers once used to milk their cows through them, especially during thunderstorms when spiritual activity is at its highest. It's also believed that if you suffer from rheumatism or any internal disorders, you should put them under your bed. Helpfully, they're also claimed to stop witches from sneaking into your bedroom and jumping on your stomach.

Sleep tight and sweet dreams!

Spooky sayings:

Behind every man now alive, now stand thirty ghosts, for that is the ratio by which the dead outnumber the living.
Arthur C. Clarke, *2001: A Space Odyssey*

Lucky stones from Brighton Beach. © Janet Cameron.

In spite of its spooks, Brighton has always been a fun place to visit. A day out in Brighton, 1938. © Janet Cameron.

Spooky Hove at night. © Gareth Cameron.

One need not be a chamber to be haunted. One need not be a house; The brain has corridors surpassing Material place.
Emily Dickinson

Don't eat wild blackberries after 29 September (Michaelmas) because they will have the Devil in them.
A country superstition

A house is never still in darkness to those who listen intently; there is a whispering in distant chambers, an unearthly hand presses the snib of the window.
J. M. Barrie, *Little Minister*

Oh! Let us never never doubt
What nobody is sure about.
Hilaire Belloc

I do not see ghosts; I only see their inherent probability.
G. K. Chesterton

The distance that the dead have gone
Does not at first appear —
Their coming back seems possible
For many an ardent year.
Emily Dickinson

Hove at night.

How often have I said to you that when you have eliminated the impossible, whatever remains, however improbable, must be the truth?
Sir Arthur Conan Doyle

Man is a microcosm, or a little world, because he is an extract from all the stars and planets of the whole firmanent, from the earth and the elements; and so he is their quintessence.
Paracelsus

An apology for the Devil: It must be remembered that we have only heard one side of the case. God has written all the books.
Samuel Butler

BIBLIOGRAPHY

E. Cobham Brewdf, *Dictionary of Phrase and Fable,* 1894

J. Middleton, *A History of Hove*, Unwin Bros. Ltd., 1979

F. Harrison and J. Sharp North, *Old Brighton, Old Hove, Old Preston*, Flare Books, 1974

J. G. Bishop, *A Peep into the Past*, J. G. Bishop, Herald Office, 1892, for 'Old Strike a Light'

Seaborne M. Moens, *Rottingdean — The Story of a Village*, 1953

www.yourghoststories.com

The Argus

The Brighton and Hove Herald

The Brighton and Hove Gazette

Guardian Unlimited, Guardian News and Media

Mail Online

Sunday Express

www.ukcropcircles.co.uk

www.ghost-story.co.uk

www.yourghoststories.com

www.ourcivilisation.com

www.jtrails.org.uk

www.sussexhistory.co.uk